THE ARTS
and the
BASIS OF EDUCATION

Bruce E. Miller
State University of
New York
at Buffalo

UNIVERSITY
PRESS OF
AMERICA

Lanham • New York • London

Copyright © 1993 by
University Press of America®, Inc.
4720 Boston Way
Lanham, Maryland 20706

3 Henrietta Street
London WC2E 8LU England

Library of Congress Cataloging-in-Publication Data

Miller, Bruce E.
The arts and the basis of education / Bruce E. Miller.
p. cm.
Includes bibliographical references and index.
1. Art appreciation. 2. Arts—Study and teaching. I. Title.
NX643.M56 1993 701'.1—dc20 93–19104 CIP

ISBN 0–8191–9127–2 (cloth : alk. paper)
ISBN 0–8191–9128–0 (pbk. : alk. paper)

In Memory of Valerie Vance

ACKNOWLEDGEMENTS

Acknowledgement is made to The Nation Company, Inc., for permission to quote from Andrew Kopkind's "Medium Gains," which first apppeared in *The Nation* magazine, 3 October, 1987.

Further acknowledgement is made to Andrew Kopkind for permission to quote from his letter to the writer of this book.

CONTENTS

Preface

Part One

Part Two

PREFACE

Reason, language, art. This is the specifically human triad of abilities. No species but our own acquires any one of these three powers, but every normal human being possesses them all. You cannot imagine a valuable human existence without them. Along with this fact that reason, language, and art are common to all but the seriously retarded goes another, seemingly incongrous, fact: each of these powers is learned. We think, we speak, read, and write, and we enjoy art only because we have been taught over a long period of time to do these things. Moreover, no matter how well educated we are, we all wish that we could do them better. And so we notice another anomaly about this triad. It is that these powers are so basic that every successful human life displays them, and yet at the same time they are so advanced, so difficult, that we all feel the need of acquiring them more fully.

Yet these three basic powers do not hold equal rank in our schools. Pride of place goes to the capacity of reason, so nearly all courses at whatever level are planned to increase students' ability to think. Thus syllabi and teaching units refer to such goals as "To acquaint students with the principles of induction" and "To help students recognize fallacies." Language ability also gets serious attention. The school curriculum gives frequent, deliberate instruction in language beginning with kindergarten and extending on through eleventh grade for all students and twelfth grade for most. In addition, the college freshman composition course, allowed to lapse in the 1960's and '70's, has been reinstated, and most colleges require their students to take it. Art, on the other hand, fares much less well. Elementary school children are lucky if they can study music for more than a semester or receive more than an occasional visit from an art teacher bringing an "art cart" of materials for finger painting, pasting, stenciling, and the like. The situation is only a little better in secondary schools. Middle schools and high schools generally offer arts performance electives, but these courses are "add ons," frills that get discarded in a bad budget year like the crepe paper on a lamb chop. Worse yet, programs of art appreciation, as opposed to art performance, are still unheard of in most schools.

This relative inattention in the schools to the claim of art to be taken as seriously as the other parts of the triad arises, I think, from a certain mistaken view of the relations of reason, language, and art to each other. According to this view, reason, the power of thought, is the basis both of language, which this outlook considers to be the expression of thought, and also of art, which is understood as a rarefaction of thought, a highly refined

quintessence. Only in the last decade or so have English teachers begun to liberate themselves from the constricting and probably false idea that reason produces language. But the equally injurious notion that art lies at the outermost bound of thought still works its mischief.

The mistaken attitude that art is the culmination of reason rather than an important source of it supports the virtual dismissal from elementary schools of serious programs of aesthetic education. After all, if art grows out of reason rather than into it, art appreciation should be delayed until reason has had a chance to develop. Thus art appreciation is denied students on the ground that they are not ready for it. This specious argument even appears to have some degree of empirical validation in the distaste which youngsters often show for classical artworks. Very few ten or twelve year olds, for example, show any signs of really appreciating *War and Peace*, the Beethoven Ninth Symphony, or the sculptures of Giacometti. Adult art lovers can misread this indifference as a permanent disinclination and forget that youngsters that age do not greatly favor soufflés or exotic cheeses either but have a robust appetite for junk food, which they will eventually outgrow. Just so with art, which also is appreciated in its refined forms only after a gradual development of taste. Another bad effect of the exaltation of art to a status beyond reason itself is that the lesser forms—folk music and folk dance, art for children, popular music, and commercial art—are unnecessarily denigrated and many people who like these forms imagine that they lack the special sensibility that would allow them to go with any real pleasure into the concert hall, the opera house, the theater, or the art gallery.

The basic argument of this book is that art grows into reason, not out of it. Art is not the consummate expression of thought, the bright flower at the tip of the stem; on the contrary, it is the taproot at the bottom, the nourishing origin which leads finally to thought in its intricate forms of question-framing, evidence-gathering, problem-solving, proof-giving, comparing, rule-learning, categorizing, and all the rest.

One would think that this view of the connection between art and reason—art as the matrix from which reason grows—could be simply stated and the justification for it succinctly expressed. And indeed I aim to be as direct in exposition as the subject allows. But the effort I have had to make in order first to understand these ideas about art and reason and then to convey them to others has convinced me that they ought to be stated in a variety of ways, not just one, and that they should be amply illustrated. Not only has my own experience taught me caution, but Susanne Langer's bad luck with some of her readers has been a warning. Langer, whose writings are the principal source of my ideas about the relation between art and reason, used the general term "feeling" to designate all mental activity whatever—whether perception, fantasy, formulation, memory, or problem-solving—and even though she was careful to define "feeling" as "anything that can be felt," still that word has led such an astute scholar

as Harold Osborne to misunderstand her.[1] In this book, in order not to circumscribe too much the conception of mental activity in all its forms, I deliberately employ a variety of terms. Sometimes I refer to "sentience," sometimes "the life of the mind," which is one of Langer's own happier expressions for it, sometimes "states, flows, forms of consciousness," sometimes "isomorph of an act of consciousness." Besides this prolixity of terms in referring to mental action, in the first section of the book I give the main line of argument more than once. I try, however, to minimize mere restatement and to make the repetitions incremental and forward moving. Chapter One describes the activity that art stimulates and shows the ways in which that activity differs from other kinds of experience. Chapter Two gives a general theoretical statement. Chapter Three illustrates the theory with a case study. Chapter Four takes the main argument of the book and applies it to the evaluation of artworks. Then Chapter Five shows that the view of art and reason given in the preceding chapters accords with and even completes a widely accepted psychology of learning.

Perhaps I can help the reader to follow the argument in the first part of this book if I offer a précis of it here. I assume that a complete mental act combines two different phases, each indispensable to the final production of a thought or emotion or intention. In the first phase the mind profusely generates life envisagements, crude approximations of what various bits of reality and different forms and functions of life might be like. Then in the second phase the mind selects certain ones of those random envisagements and adjusts and refines them so that they gradually come to resemble the world as it actually exists. The two phases operate somewhat like cans of spray paint and a set of stencils. The cans of spray paint splatter their contents every which way, but the stencils distribute the paint so as to make an x, a y, a z, and so on. Thus, mental action borrows from two great reservoirs of symbols, each corresponding to one of the two phases. One reservoir (the spray paint) is the *presentational* symbols which are mostly about the mind itself, presentations of its spontaneous functioning during the first phase of action. Mainly these symbols are preserved in art, though certain other kinds of experience are also a part of this reservoir. The other reservoir (the stencils) is *discursive* symbols about the world and its ways. These latter symbols are preserved in language. To a small degree we add our own mite to the reservoirs when in our dreams or in some idiosyncrasy of language we invent a novel way of imagining or identifying aspects of reality. But in the main the reservoirs are public, not private, art holding the presentational symbols and language the discursive.

Reduced to its essentials, my argument is that art is a lower stage of symbolizing which, once it comes under the tutelage of language, which is a higher stage, becomes reason, the highest stage of all. Thus, the triad of art, language, and reason, each universal to humans and yet each learned, is also a pyramid of mental abilities. Art—I mean the appreciation of art—is at the base, for it leads to the preliminary shaping of consciousness; language is a long step forwards in human dealings with reality; reason is the full ac-

commodation of the mind to the world. Art, along with language, is the basis of education because it is the ground from which reason grows. These ideas about the mind are not new. They would not have surprised Percy Shelley, for instance, whose *Defense of Poetry* expresses the notion that presentational symbolism, or *imagination* as Shelley calls it, underlies reason.[2] Nor would they have surprised Matthew Arnold, who reproved Bishop Colenso for taking the Bible literally and not realizing that the "truth of religion" [presentation] is different from the "truth of science."[discourse][3] In more recent times the outstanding exponent of these ideas has been Susanne K. Langer. Langer's earliest philosophic interests were logic and epistemology, but in her still influential *Philosophy in a New Key* (1942) she merged her interest in theory of knowledge with aesthetics, for by then she saw that reason, or discourse, is founded on a preceding intellectual activity, presentation, that reveals its nature in art, ritual, and myth. She further developed her aesthetic ideas in *Feeling and Form* (1953), and then in her old age this extraordinary thinker gave a comprehensive account of the full range of human intellect in the three volumes of *Mind: An Essay on Human Feeling* (1967; 1972; 1982).[4] Among numerous borrowings from Langer in this book are the distinction between presentation and discourse and the idea that the thing which artists create in their works is virtuality or semblance. But, like the best intellectual leaders, Langer is a liberator, not a vanquisher, and so this book develops a theory of aesthetic education which, though true to her ideas in general, on some points diverges from her.

When I began to study Langer years ago, I myself was slow to accept the ideas about the relation of art and reason which I am now expounding. My reluctance arose because I conceived of mind in a way which was popular then and which is still tacitly accepted by many. This conception envisages mind as a product of the brain, which a psychologist in those days once described to me as nothing other than an exquisitely delicate weighing machine. This view of the mind as an inert copying device is supported by a surface probability, for our senses do seem to take generally reliable impressions of reality, and we make likely inferences about the imperceptible from those sense impressions. But some studies of the mind suggest that the crudely mechanistic view needs to be much modified if it is to describe all mental behavior accurately. In *Philosophy in a New Key* Langer pointed out that the frequency and persistence of error among humans is not compatible with a mental organ that makes a direct and unequivocal record of the world. She mentioned that no other species than humans, trekking across country and coming to an impassable mountain range, will light a bonfire and prance around it in the confident expectation that the mountains will fall down. This is an error of interpretation, but humans often make even more simple errors of perception. For instance, in summer it is a common occurrence to look down a country road and see what one takes to be a dead animal, which on closer view appears to be a puddle of water, then a gauzy shimmer of vapor, and finally noth-

ing at all. There is another peculiarity of mental life which the psychology of mind-as-camera will not explain, and that is the fact of ambiguity. Whereas a camera or tape recorder gives just one version of an event or situation, the mind very often gives two or more. Ambiguity, the seeing two or more versions of a thing at the same time, is the secret of much verbal comedy. "This clock will run for eight days without winding," says one comic. "How long will it run if you wind it?" asks the other. A more learned example of ambiguity which linguists often cite is the implication of two quite different meanings in the sentence, "Flying airplanes can be dangerous."

More recently the view of mind as an active principle organizing the givens of experience into knowledge has gained the support of weighty exponents—in addition to Langer, such psychologists of child development as Piaget and Vygotsky and the psychiatrist Oliver Sacks.[5] This new conception of mental life has deeply affected education; in the teaching of reading, for instance, it is now generally understood that readers at every level are active in producing meaning and are not just passively receiving it. The place of the arts in basic education becomes magnified when it is seen from the standpoint of the contributions that seminal thinkers have been making to the understanding of mind.

Part Two of this book is easier to summarize. It deals with the practical consequences for teaching that derive from the views of art and its effects given in Part One. It asks what is a good art life, how much art, for example, such a life requires. It outlines some contributions that families, schools, and communities can make in order to infuse art into the regular pattern of a person's living. It examines the constituents that should enter into a program of art appreciation, inquiring into such questions as how desirable it is for a student to perform an art in order to appreciate it and to what extent formal instruction in aesthetics and criticism enhances a person's art life. It considers the feasibility of a set curriculum in arts education. Finally, it offers some materials that one arts-in-education organization has developed for teachers who want their students to achieve maximum benefit from the experience of artworks.

The two parts can be read separately to fulfill different interests, Part One as a theoretical defense of putting much greater emphasis on art appreciation than now exists in the schools and Part Two as a handbook for instituting aesthetic education programs and for guiding students' interest in art. Read in this way, the first part will mainly concern arts educationists and curriculum specialists while the second part will interest classroom teachers and artists in the schools. On the other hand, I have conceived the two parts in close relation to each other, and I hope that they will be read together, the first part anchoring in serious conception the practical suggestions that come later, the second part testing the theory and showing that it has fruitful implications for teaching. Teachers should read the first, theoretical, part so that they can increase their effectiveness by contem-

plating the reasons that make art worth teaching for appreciation, and specialists in art education and curriculum theorists should read the second, practical, part in order to realize what pedagogical consequences aesthetic principles can produce.

Valerie Vance, to whose memory this book is dedicated, was Executive Director of Young Audiences of Western New York, an organization which brings performing art into the schools in Buffalo and the surrounding area. She was alive and very active when I wrote this book, and I planned to dedicate it to her partly to acknowledge my gratitude to her for saving me from embarrassing blunders in my comments on music, partly to express my admiration for her work in the field of aesthetic education, but most of all to please her, for she delighted generously in any achievements of her friends. Now she is gone, and the pleasure I had expected to give to her I must reserve for myself in remembering her.

FOOTNOTES

[1]Harold Osborne, *Aesthetics and Art Theory: An Historical Introduction* (1968; New York: Dutton, 1970), 246-249. Although Osborne writes respectfully of Langer, he underestimates the consistency of her argument because he confuses "feeling," which is Langer's term for any psychic process, with the more narrow meaning of "emotion."

[2]Shelley's essay, left incomplete and never published in his own lifetime, is available in a variety of places, one of them being *Shelley's Critical Prose*, ed. Bruce R. McElderry, Jr. (Lincoln: University of Nebraska Press, 1967).

[3]Matthew Arnold, "The Function of Criticism at the Present Time," *The Complete Prose Works of Matthew Arnold*, ed. R. H. Super (Ann Arbor: University of Michigan Press, 1962), 3:76-77.

[4]Susanne K. Langer, *Philosophy in a New Key: A Study in the Symbolism of Reason, Rite, and Art*, 3rd ed.(Cambridge, MA: Harvard University Press, 1957); *Feeling and Form: A Theory of Art* (London: Routledge & Kegan Paul, 1953); *Mind: An Essay on Human Feeling*, 3 vols. (Baltimore: Johns Hopkins University Press, 1967-1982).

[5]Jean Piaget, *The Language and Thought of the Child*, trans., Marjorie and Ruth Gabain, 3rd ed. (London: Routledge & Kegan Paul, 1959); Lev Semenovich Vygotsky, *Thought and Language*, ed. and trans., Eugenia Hanfmann and Gertrude Vakar (Cambridge, MA: M.I.T. Press, 1962); Oliver Sacks, *The Man Who Mistook His Wife for a Hat and Other Clinical Tales* (New York: Summit Books, 1985).

PART ONE

CHAPTER ONE

The Experience of Art

Three Kinds of Experience

John Dewey asserted that art is not "experience" just the ordinary flow of life, but "*an* experience," that which defines itself by standing apart from the flux of things.[1] Other commentators on art agree. They may, like the Scholastic philosophers, emphasize its quality of brilliance or wonderfulness, or they may with the Kantians, remark its transcendence of ordinary sense experience, or, following Croce and other intuitionalists, they may stress its uniqueness.[2] The theme common to nearly all writing about the nature of art is that to an unusual degree artworks stand out in our lives, loom up, offer themselves to a close, prolonged, and passionate inspection that we rarely accord to anything else.

Why should art have this character of *an* experience, an occasion standing out and highlighted against more ordinary surroundings? We shall need to investigate this question before we can recognize the role that art plays in the drama of mental life. The first step towards our answer is to see how art differs from other experiences. One way of classifying experiences is to divide them into the categories of working, playing, and attending, the principle of this division being the relation between the *process* of the activity, its on-goingness, and the *product* of it, its result.[3] In the case of working, the process goes in a straight line to the product. First the cook assembles the ingredients, then she puts them in the oven for a certain length of time at a certain temperature, then she takes out the cake. Something close to this scenario describes every case of work, whether it is digging a ditch, flying an airplane, or writing a term paper. The worker gathers material—picks and shovels or maps and fuel or ideas and scholarly conventions—arranges it, subjects it to certain conditions, and as a consequence of the process achieves a product—a ditch, a flight, a term paper. Once the product emerges the process is over, and so the two, process and product, are at last separate.

The extreme contrast is play, which makes the process and the product identical; just the process, the activity, is the goal. Children's games are the clearest example of pure play, an exultation in mere activity

for its own sake. But the play impulse rarely, if ever, vanishes altogether. Most people participate in sports and games just for the fun of it, not for any ulterior motive. At least for amateurs, the addition of a bet of money on the outcome of their poker games or tennis matches only intensifies the pleasure of the activity itself; it is not an end for which they undertake the activity. The existence of professional athletes and game players does not contradict the notion that play is its own end. Either the professionals are working for money, not playing, or else they really are playing, delighting in the game for itself and just accepting the prize money as manna from heaven.

The third category of experience, attending, combines the main feature of work with the principal characteristic of play. It resembles work in that the process, the activity, really does lead to a product. But whereas the product of work continues to exist after the process creating it is ended, the product of attending, inextricably attached to the process, endures only as long as the particular spell of attending lasts. This is the practical reason for the Biblical injunction, "Pray always." If you want to be entirely thankful or deeply contrite or utterly adoring, the only way to do it is to live constantly in prayer or very close to that experience. Similarly, we surround ourselves with occasions for attending to patriotic imports: public monuments, the national flag, parades and other civic or military ceremonies, national holidays, *The Star Spangled Banner* played at games and sometimes the theater. In wartime, when the need for patriotism increases, these occasions become even more frequent and diversified.

The appreciation of art is one kind of attending. Other kinds are watching sport (but not engaging in it directly; as we have seen, that is either play or work), taking part in religious observances, and studying nature. We see at once that these experiences of attending have certain features in common which mark them off from experiences of playing and of working. For one thing, the attending experiences are very serious as compared with play. When we watch a ballet or go to church, for example, we feel that we are doing something that is more important than what we are doing when we play a game of bridge. Yet, compared with work, attending is not self-centeredly practical. We work for tangible benefits, such good things as supporting ourselves and our families, keeping the house in decent shape, gaining the respect of superiors and colleagues. Those are not motives for attending however. Although we know that watching the sunset is in some way good, we also know that it butters no bread and pays no bills. It does nothing *for* us; it does something *to* us. Another characteristic of attending is its intensity. In both working and playing we have to concentrate closely at times, but generally an experience of attending is more high-strung, more demanding on our powers. This greater intensity of attending may account for its standing out in our lives in distinct experiences. Probably you cannot recall vividly what you did at work a week ago or what exactly happened in your best game of tennis that you played recently, but you are likely to remember the selections at a concert

you heard last week and your response to them or the peculiar shape, color, and volume of water in a stream you watched a month ago on an outing to a state park.

Attending

So, then, experiences of attending are marked by seriousness and intensity. Of course work is serious too (but typically not to the same degree as attending—how serious can you be about washing a car or balancing a checkbook?), and play can be very intense. Attending, however, combines both qualities of seriousness and intensity. In addition, attending shows a third, especially distinctive characteristic, for which I have named the experience itself: it is the control that an external object exerts over our attention. We really do attend to these experiences, give them our full minds and hearts.

A striking aspect of artworks is their power to arouse and then sustain our interest. In our normal state of consciousness we attend to things superficially, taking in just enough detail to keep us out of trouble. We can do such work as driving a car, waiting on table, or cleaning a room with a minimum of thought, so these things occupy only a part of our minds, the other part operating in some entirely different activity, fantasizing perhaps or planning the rest of our day. Even high level thought consumes intellectual energy only in spurts so that, for example, when we work on our income tax reports, we take a break every fifteen or twenty minutes and turn to something else for a while. Students generally do their homework assignments in that fashion, and good teachers plan their classes to allow for this alternation of concentrated attention with brief respites. Television, notorious for its tolerance of people's inability to pay attention, splits its presentations into even shorter segments.

By contrast, experiences of attending intensify and prolong attention. Of the four forms of attending considered here (experiencing sport, ceremony, nature, art) watching sport is most like art in its intensity. But there are differences. At a sports event like football or tennis the observers' excitement usually exhausts itself in overt activity—shouting, applauding, perhaps even jumping up and down—whereas the experience of art confines the feelings and thus forces them to still higher intensity. In addition, sports tend to spread attention out over a larger field of perception, a whole swimming pool or a basketball court, which themselves blend into their surroundings of bleachers, gymnasiums, and audience, while art localizes it onto a particular painting in a frame or a particular action on a brightly lighted stage.

Civic and religious ceremony, though it rarely attains the outward excitement of sports, seems to offer experience which in other respects is

more like the experience of art. Like artworks, religious ceremonies are enclosed in a controlling environment which helps to focus the mind sharply on just one thing—the set of actions at the altar. But religious ceremony, like sport, does not duplicate the experience of art. The relationship between the audience and the things that they witness is the main difference. With respect to an artwork we can always "take it or leave it." If a particular artwork matters to us, we will go into it very deeply, but if another work lacks appeal, we will ignore it cheerfully, for in neither instance are we going to make any conscious practical use of the work. That certainly is not the case with the ceremonies of those religions and political systems which we accept, where such freedom would be considered blasphemous or seditious. In respect to this difference, art seems to be a strikingly unconstrained activity. In addition, deliberate external reference—obvious, declared meaning—is much more apparent in religious ceremony than in art. A genuflection in church, for instance, more distinctly alludes to a reality, God, which is felt to exist independently of the action than a musical composition or even a painting alludes to any real thing in the world. A painting can always enhance its subject, touch up aspects of it which the artist doesn't like, but a religious ceremony which did the same thing would be unthinkable. Both the ceremony and the artwork have significance, but in different ways. Indeed, some aestheticians have made a good case, one which I accept, that artworks do not mean at all in the ordinary sense of making statements about real things in the world. Therefore when I discuss significance in art I shall speak of *import* rather than *meaning*.

Nature study comes even nearer to art than either sport or religious ceremony. Like the other attending activities, it greatly increases our attentiveness, but the experience of nature especially resembles art in its noumenal character, its quality of seeming to present to us something that transcends the particular object or event that embodies it. This noumenal character which marks both nature study and art is such a common experience that rather than try to define it formally I can better suggest it by giving an example. Many years ago a friend and I drove along the southern shore of Lake Ontario at the time of year when the Canada geese were migrating northwards, and to see them better we stopped and got out of the car. They seemed to be everywhere. Huge flocks of them browsed in the fields, and overhead countless numbers flowed onwards like rivers, miles wide, that poured from the south to the north as far as we could see. Both of us were overwhelmed, and to this day, long since, we can recall the episode and its feeling-tone. Its import has something to do with abundance and with a mindless but somehow intentional perseverance. I cannot further specify that general statement. I hold the meaning not in any formula of words but in the images of birds browsing, the misty gray lake shore, the flocks flowing northwards endlessly. And it is just the same with the artworks which are most important to me: each embodies in sight or sound some particular stance of mind that would otherwise be inexpressible and, for me, unavailable.

Art and nature affect us in a similar way because they both overflow with import. Whereas such ordinary language as a closely argued editorial or a persuasive legal brief says just so much and no more, objects of attending—a mountain or a novel—well over with suggestion. But we also notice an important difference between the two objects of attending, the mountain and the novel: the fact of communication. Natural objects are significant to us because we, the appreciators, give them import; artworks are significant because we appreciators *along with the artists* give them import. This coming together of the consumer with the maker in the production of significance suffuses artworks with personality, their creators' personalities as well as their appreciators'. All fine artists are distinctive in their work. There is something characteristic in a painting by Michelangelo that excludes Raphael and Leonardo. Beethoven was Haydn's student, but Beethoven's symphonies and string quartets are recognizably different from Haydn's, and the difference increased as Beethoven grew older and more fully attained his own manner. Thomas Hardy especially admired the poetry of Shelley, and yet a poem of his as Shelleyan as "Shelley's Skylark" is clearly Hardy's poem, not Shelley's.

Thus far we have brought together some observations about art experience which allow us to make at least a provisional definition. For one thing, we have noticed that art experience *contains* its product, in contrast to work, which *emits* its product, and to play, which *is* its product. Furthermore, we have seen that in art experience our attention, to an unusual degree, is intensified, prolonged, shaped, and filled with a sense of significance. To put it more briefly, then, apprehending art is an experience of attending which is particularly intense, controlled, and noumenal.

Pleasure in Attending

Now we need to elaborate this basic definition by examining the experience more closely. When we do that, we find two additional characteristics, pleasure and creativeness, and we notice that they both have very distinctive peculiarities that distinguish them from the pleasure and creativeness that exist in other contexts.

First, take the sensation of pleasure. The enjoyment of art clearly gives much pleasure. If it did not, then we would not pursue art at all since, unlike work, it is a purely voluntary activity. But pleasure in art is mixed with discomfort, sometimes acute. Some of the greatest artworks require us to study them with painful concentration and strained memory in order to take them in at all, and these strenuous mental exercises are the very opposite of the joyful letting go that occurs in play. Moreover, these works often convey sensations which restrain our feelings rather than release them. The involuted writhings of *Laocoön,* the strained, suffocated gasps at the end of Tchaikovsky's *Francesca da Rimini,* the pointless and

nameless sufferings in the dusty, closed environments of Kafka's *Trial* and *Castle* leave us breathless from constriction of spirit, not expansion. Even comedy, when it rises above the level of idle entertainment, surprises us with a pang of discomfort. Jack Benny used often to elicit that discomfort with a sudden and humiliating revelation of character weakness, and Fred Allen would haul some victim out of his stable of misfits called "Allen's Alley" for a cold demonstration of pathetic deficiency. Today Woody Allen disturbs us by showing the outer, funny side of neurosis but aligning it at the same time with a presentation of the dark, inner side in one bittersweet moment. This happens in *Annie Hall*, for instance, when Allen's character goes berserk in the parking lot of a Los Angeles restaurant, first ramming his rented Cadillac convertible against the other cars, then tearing up his driver's license in the face of the policeman who has come to arrest him, and finally, contrite and insolent at once, getting bailed out of jail. The British comedian Benny Hill had his own ways to evoke discomfort. One way was to present characters who oddly mix together features of coarseness and refinement; another was to show a lover in ardent pursuit of a girl and then at the last moment to defeat him or to let him win the girl but to reveal that she was not at all what he had thought. The clown Emmett Kelly also worked discomfort into his act. His artistic greatness was not in his pratfalls—we all look about the same tumbling onto our backsides— but in getting up in such a way as to give the audience a twinge of shame for laughing at his mishap.

Our experience of art, then, though pleasant, is laced with a considerable amount of discomfort. Indeed, I think that at least some unpleasantness must inevitably accompany our experience of an artwork, at least in the early stages of our coming to know it. In the next section, when we notice the creative work of the audience, we shall see why this is so. For the present, however, we should return to the fact of pleasure, for it is an important fact. Art and the other experiences of attending convey a quite different pleasure from either play or work. If, as the Freudians have taught us, pleasure is basically the release of energy, then play seems to be the most simple case, for play, whether it exists as the quiet calculation of a chess game or the excitement and exhaustion of a game of hide-and-go-seek, releases energy in a direct outflow. In some cases work has the same characteristic. Physical labor that is not excessive can be positive fun, as in shoveling snow off a sidewalk. A further motive of pleasure is added when work is well done or when it is important, for then workers can feel proud of themselves for being equal to the task or for carrying out a vital function. So successful work causes self-approval, which is always pleasant.

Creativity: Constituting the Artwork

The pleasure involved in experiencing art seems quite different. It cannot be play's uninterrupted release of energy, for art often bottles up

energy and frustrates its release. Nor can art experience give us the sense, conferred by some kinds of work, that we have benefited others. Yet in experiencing art we have a scope for releasing tension at a higher level than play or even work in most of its forms. In experiencing art we have creativity. Creativity is a special thing. To be sure, the word itself has been debased so that we talk of a cook's "creations" and of "creative financing." We really know better than that however; cooks and bankers do good work, but in their professional capacities they certainly are not creative in the sense we are using the word here. To be importantly creative is to make a *unique intelligible object*, a really new thing which exists as a construct within the mind. Very often that construct will have a material reflection out in the world, as the Salk vaccine or the various kinds of mini computer. But those material objects merely derive from the mental states that preceded them. The vaccine existed in Dr. Salk's mind before it ever was injected into a body, and the mini computers are material descendants of an abstract idea in the mind of Turing[4] as modified by others (important intelligible objects are often communal, not private, property) who caught the idea, elaborated and refined it, and then applied it to making smaller and yet more powerful machines.

The purest exemplars of creativity in the grand sense of making intelligible objects are the great scientists and artists. Galileo made a model, a mental construct, of the possibility that the earth moves; then he and others saw that the model is true. The debris from a junked bicycle stimulated Picasso to model a different kind of possibility, and hanging the unpadded frame of the seat tip down and stringing the handlebars through the broad end of the seat, he expressed a state of consciousness—an intuition of unreflecting, self-contained, independent power—in a sculpture that he called *Bull's Head*. The scientist's intelligible objects model things that exist or might come to exist in the outward world of reality, and the artist's intelligible objects things that exist or might come to exist in the inward theater of mind.

Creativity at that level is awesome, unaccountable, and in fact no one has ever satisfactorily explained it. Consumers of science and art do not have to create on that extremely high plane of originality. Their activity is different. Instead of originating the intelligible object, they grasp this object that the scientist or artist has made; they reconstruct it in their own minds. When we grasp the one kind of object we say that we are learning a scientific principle, and when we grasp the other kind we say that we are apprehending the artwork. This apprehending is an important kind of creation, for it involves a making within the mind and even, as I shall try to show in later chapters, an extending of the capacity of the mind itself. For now, we can say of artistic apprehension that it does seem to explain both the pleasure of our experience of art and also our discomfort, our at least occasional displeasure. Art experience is pleasant because it involves a very high mental function, making within the mind, genuine creativeness,

but it is also sometimes unpleasant because it overtaxes our mental power as we try to create what, for us, are new mental objects.[5]

I am going to give the name "constituting" to the activity by which audiences create artworks in the mind. Before saying anything more about it, I shall try to show that constituting does really happen, that when we experience an artwork we actually apprehend an object *in the mind* (not merely in the outer world), and that we ourselves help to create the object that we apprehend. To begin, here is an example that will help to clarify the idea. An ancient Greek statue which nearly everyone has seen in photographs is the famous Venus de Milo. Now, that statue as it exists today in the Louvre lacks both arms, for, having been much the most slender parts and but lightly anchored in the massive central section, they have been severed just below the armpits and are forever lost. So much for the mutilated Venus de Milo as it exists in the real world, in the Louvre. But what of the same statue as it exists in our minds, does it have arms? Of course it has, and all of us agree precisely where the arms are placed—Venus puts them exactly where we would expect any grand lady surprised in her bath to place them. And this placement of the arms, which no longer exist in reality, accounts for the way the statue affects us—its provocativeness, its coy allure. If Venus threw her arms wide apart, she would be a trollop; if she gripped them tightly around her body, a prude; but just as she stands with the arms negligently concealing herself, she embodies the demure, serene power faintly honored by our prurience but mainly indifferent to it and us. But what of Venus's arms? We can hardly say that they are real, for they would not show up in a physical measurement of the statue as it now exists. But neither can we say that they are imaginary in the ordinary sense since they are not just optional extras that we add on or not as we think fit. They are neither exactly real nor exactly imaginary; these constituted arms are *virtual*, certainly located on the statue as governing our aesthetic apprehension of it but not there when we measure it.

From this simple example of a particular virtuality in an artwork we can go on to whole classes of virtual qualities in the different domains of art, for each of the major arts characteristically emphasizes one kind of virtuality or other. Music cultivates the virtuality of time. In the real world two conceptions of time operate. The primary conception is inseparable from our idea of movement. Thus rapidity of movement is the decisive factor if the policeman gives you a ticket for driving too fast in a school zone or if the coach says that a boy or girl is too slow to become a good runner. The other conception of time, derived from the first, involves measuring the duration of an event by comparing it to some regular, invariant movement, normally the clock. I have this conception in mind when I say that I teach some *short* classes (fifty minutes) and some *long* classes (two hours and a half). As applied to music, we use this derived conception of time when we say that "Flight of the Bumblebee" is short and the symphonies of Bruckner long. In such a statement as that we are talking about real time, not virtual. This is not the conception of time which we most often use when we

listen to music however. We do not think of "Bumblebee" as short; we think of it as fast, and a typical movement of a Bruckner symphony—the last (third) movement of the Ninth say—is not so much long in our perception of it as it is slow. Moreover, some musical pieces that are by actual measurement long, like the last movements of the Beethoven Seventh and Ninth Symphonies, are felt as moving very fast. But in fact, though it is almost impossible to realize this as you are listening, music does not move at all; it isn't going anywhere. When we speak of a particular piece of music as "fast" or "slow" we are making *virtual* sense of it but *realistic* nonsense, for a musical selection is whatever length of time the clock says it is—five minutes, ten minutes, fifteen. The virtuality of what we hear, however, predominates in our minds over the real factor, so much so indeed that even as we remind ourselves that there is no such thing as "slow time" or "fast time," we positively hear the music begin in a slow wavering, pick up speed, dash forward, come to a sudden halt, resume uncertainly as at the beginning, shift into a steady progress, die away evenly, all of which realistically is impossible.

If the virtuality of music is time, the distinctive virtuality of the graphic arts is space. As I write this I am looking at a reproduction of a painting by Thomas Eakins, *Max Schmitt in a Single Skull*. It is a river scene showing Schmitt in a boat resembling a kayak but equipped with two sweeps fixed in oarlocks. Schmitt, not far from the viewer, not more than twenty or thirty yards, has stopped rowing and has partly turned around to look at us over his right shoulder. The boat is aslant to us, its bow pointing obliquely to our left. About fifty yards behind Schmitt another rower of a similar boat is energetically pulling away from us. Farther back, about four or five hundred yards from us, three holiday makers in a more conventional boat are rowing out onto the river. Farther back still, not very far behind this party of three, are two railway bridges close together. We see only a part of the farther bridge, however, because a bend in the river interposes some land that cuts off our view. If you can locate a reproduction of this painting, I am pretty sure that you will find my description of it faithful.[6] I have left out a number of details, of course, but the ones I have included in this account are there in the painting, including the approximate distances. If you look at the painting, you will find it hard *not* to say that Schmitt is near us, that one boat is farther back from us than his, that another boat is farther back still, that the railway bridges are behind the farthermost boat, and that a full view of the second one is interrupted by the winding river that lies before us and recedes into the distance. All this space in a painting that measures 32" by 46"! Considered really, as a physical fact in the actual world, pictures have a dimension from side to side and from top to bottom but scarcely any depth at all, at most half an inch of canvass and paint. But considered as they appear to us—apprehended in their virtuality—the dimension of depth is so convincing that we see a certain object in a picture as such-and-such a distance behind or in front of some other object. And the virtual space of a picture also supervenes over the real vertical and horizontal measurements so that Eakins'

moderate size painting gives a river scene reaching up into the sky and a considerable extent of land. When we see this picture we do not feel that we are looking at a model or a clever miniaturization; we feel that we are looking into space. Moreover, the presence in a single room of several such pictures, each evoking great reaches of space, does not surprise us at all; normally we do not even notice the anomaly. That is the power of virtuality in art.

The various art forms exploit distinctive virtualities. Literature features the virtuality of memory, making us think that plots and characters are recollections of events and people, not a poet's or novelist's invention. Dance exemplifies the virtuality of force, giving us images of the inception, growth, flow, interruption, collision, fusion of energies far surpassing those which the actual dancers could really produce. More important here than identifying the virtualities of the different arts is realizing that artists and audiences work together to bring these virtualities into effect. What the artist does is present the framework, and what the audience does is fill out that framework from the resources of its imagination. This filling out is what I call constituting.

My own teaching of literature illustrates the constituting of a work as a sort of joint activity of myself, the critics I have read, and my students. In a course on English Romantic poets, teaching John Keats's ode "To Autumn," I remarked to the class that the three stanzas of the poem follow the progress of the season from the early autumn ripening of Stanza One to the harvesting of Stanza Two to the decay of Stanza Three, an observation which I had learned from an essay by Leonard Unger.[7] As soon as I made this remark about the progress of the season, an exceptionally sensitive student pointed out another time schedule, the advance of the day from early morning of Stanza One, to high noon of Stanza Two, and finally to the twilight of Stanza Three. Then these observations about the different time sequences united in my mind with my interest in the many images either of ripening or of dying which "To Autumn" contains, and as the class and I talked about the various time patterns and life cycles we began to see much greater and clearer significance in certain images of the poem which before had eluded us. This class demonstrated the activity that goes on when people apprehend an artwork. Partly they "take it in" in the way that a camera films an object, but they also do much more than that, for they also "make it up." Apprehending an artwork, really seeing or hearing all that is there, requires this more active participation by the audience because art *objects* are only the physical designs that the artist made, whereas art*works* are the ideas, the intelligible objects, that audiences constitute in their minds out of suggestions implicit in the physical objects. Thus, a piece of art begins as a material thing external to ourselves, but as we build it up to its fullest possible existence in our minds by constituting it with virtuality—arms in the case of Venus, the passing of time in the case of "To Autumn"—it also becomes a happening, an event that has all the

vitality of something we really do, not just an object that is only something we watch or hear.

A Definition of the Experience of Art

Now we can try to complete our definition of the experience of art. Certainly our definition should include the point that art experience is a kind of attending in which mental energy is controlled and intensified to an unusual degree. The definition should note that ultimately this object is a thing which the audience build up in their own minds by internally adding details to the outline specified in the external art object. And finally the definition should refer to the sense of significance which permeates experience of an artwork, our sense that the contemplated object matters importantly. This sentence contains the main points: The experience of art is an intense and noumenal attending controlled by the object of contemplation, which itself is mentally constituted by the audience out of suggestions contained in a physical object which has been made for that purpose.

FOOTNOTES

[1]John Dewey, Chapter III, "Having an Experience," *Art as Experience* (1934; G. P. Putnam's Sons, 1958).

[2]A readable account of thinking about aesthetics over the ages is Monroe C. Beardsley's *Aesthetics from Classical Greece to the Present: A Short History* (1966; rpt. University, AL: University of Alabama Press, 1975).

[3]The definitions in this three-way distinction are borrowed from Curt J. Ducasse, *The Philosophy of Art* (New York: Dial Press, 1929). Ducasse discriminates three different kinds of activity: ectotelic ("work" as I call it here), autotelic (which I paraphrase as "play"), and endotelic (art apprehending and the other contemplative states).

[4]The life of this extraordinary mathematician is given in Alan Hodges' *Alan Turing: The Enigma* (New York: Simon and Shuster, 1983).

[5]The paragraphs that follow combine Susanne Langer's idea that what is created in an artwork is a "semblance" or "virtuality" with Roman Ingarden's notion that audiences "concretize" an artist's skeletal *art object* into a fully fledged *work of art*. The pertinent writing of Langer is Chapter 4, "Semblance," in *Feeling and Form*. Like Langer, the Polish aesthetician Roman Ingarden was a learned and voluminous writer, but he himself clearly expounded his leading ideas about art in a succinct essay, "Artistic and Aesthetic Values," appearing in *Aesthetics*, ed. Harold Osborne (London: Oxford University Press, 1972), 39-54.

[6]This painting is reproduced as Plate Number 8 in Fairfield Porter, *Thomas Eakins* (New York: George Braziller, 1959).

[7]"Keats and the Music of Time" in Unger's *The Man in the Name* (Minneapolis: University of Minnesota Press, 1956), 18-29.

CHAPTER TWO

What Is Art Good For?

What Art Cannot Do

Like the two other universals of human behavior, language and reason, art has many different uses, but in this book I am concerned with art only as it helps us to develop our minds. Undoubtedly, art has functions which I overlook here. For instance, art certainly conveys to its audience a heavy load of the beliefs which anyone must hold in order to operate successfully in a particular culture, such information as the acceptable relation of the sexes and the generations, the allowable degree of assertiveness, the expected sacrifices for the social good. Art also seems to be psychologically therapeutic, at least under some conditions. I shall deal with neither of these functions of art, not because I doubt their reality or their contribution to a good life but rather because I do not consider them to be as directly related to basic and liberal education as the functions which I shall explore.

But although art can do many things, there are also things which it cannot do and which should not be claimed for it. I think that art cannot really perform two functions which are often attributed to it, and I want to dismiss these false pretensions before getting on to the claims which I think are justified.

Many people seem to think that art refines the feelings. For instance, mothers often get their daughters to take ballet lessons in the belief that the experience will help them to become ladies, and the common use of the words "sensitive," "sensitivity," and "sensibility" in discussion of art implies the notion that art educates the emotions. Superficially, this relation of art to emotion seems reasonable. It makes symmetrical equations between all the major school subjects and desirable educational outcomes, scientific and humanistic education corresponding with cognitive development, aesthetic education with affective development, and physical education with motor development. And indeed artistic experience may correlate with a trivial kind of refinement. At least I suppose that most of us would trust an arts major farther than an engineer or a dentist in decorating our homes. Even that is not certain however, and the deeper, really important level of feeling that we might describe as *just* or *honorable* or *proper* seems to have no connection whatever either with the study of art or with

any other academic work. Learned and artistic people are quite as capable of cruelty, selfishness, and deceit as the ignorant and inartistic. It would be hard to say what causes the difference between high, fine feelings and coarse ones, but casual observation shows that neither art nor scholarship makes the difference. We can say almost conclusively that the girl sent to dance school, if it is a good one, will acquire valuable learnings, but being a lady in the normative, ethical sense will not be one of them. That is beyond the reach of art.

The subject of the connection between art and morals has been discussed for ages, and some writers on it have reached conclusions different from the one just stated.[1] Perhaps a step towards clarifying the issue is to distinguish between morality, or doing good, and ethics, or having ideas about the good. The ancient Greek philosophers considered the effect of art on morality. In Book Three of *The Republic* Plato argued that the right kind of music leads to a proper moral disposition in its hearers by calling forth and ordering emotions through rhythm and harmony, and Aristotle, somewhat obscurely, seems to make the same argument in *Politics*, Book Eight, Chapters V-VII. Their view was revived and generalized to the other arts in I. A. Richards' *Principles of Literary Criticism*.[2] Richards argued that an artwork stimulates in the observer a massive neural response and then organizes it into a harmonious whole which is far healthier than the discordant impulses that ordinary life evokes. The weakness of all such theories of the normalizing function of art, it seems to me, is that aesthetic response does not continue long beyond the actual experience of the artwork. Although there exists some amount of afterglow, the first fine rapture of direct experience dissipates quickly. So although artworks certainly do have affects, those emotional responses are too brief to constitute a moral habit or attitude.

There may be a stronger argument for an ethical rather than a moral effect of art. Harry S. Broudy[3] has suggested that such a basic ethical notion as fairness may derive, by analogy, from aesthetic fairness, that is, from the balance or fitness in an artwork or other object experienced aesthetically. That may well be so, and the whole subject of artworks as isomorphs of mental processes deserves more investigation. The subject has already been touched on here, and Chapters Four and Five will deal in some detail with the capacity of artworks to model acts of consciousness that go into reasoning. Nonetheless, the distance is very wide indeed between the adumbration which an artwork makes of an isolated act of consciousness and the intricate coordination of many mental acts into a complete ethical argument. Take, for instance, the disagreement on income tax policy between the flat taxers who think that everyone ought to pay the same percentage of their income whether it be twenty thousand dollars a year or twenty million and those exponents of the graduated tax who say that the rich should pay a higher percentage of their incomes than the poor. All agree that whatever rate is imposed, flat or graduated, should be fair, but

the question what is fair can only be answered by a highly complicated argument, and the aesthetic analogy will take us but a little way. It is the same with ethics as with any other kind of high order thinking. The indispensable ground of thought is presentational aesthetic experience, but the superstructure has to be purely rational discourse.

A second misconception about the function of art which I want to discount is the notion that art is a secret code revealing some higher truth that the ordinary language of newspapers and magazines, classrooms and textbooks cannot express. Such words as "inspiration," "epiphany," "intuition," and "insight" are often used to convey this idea that art mystically unveils higher knowledge to those initiates who have the special power of deciphering it. This view fails, I believe, because it incorrectly assumes that art is a language. The notion that art is a gnostic language known only to sophisticates implicitly distinguishes between the ordinary truth that words can declare and some higher truth that can only be given in the special language of painting or music or dance. But in fact none of the arts is a language.

Language possesses two essential properties which distinguish it from the arts. One is words, markers that arbitrarily and invariably point to the same thing (or a limited number of things in the case of words used metaphorically). Thus words like *boy* or *hat* or *window* have pretty much the same "meaning" in all uses (allowing for a slight analogical extension such as *tomboy*), but middle C on the piano or a shadow in a painting or a massing of volume in a particular part of a building do not "mean" with anything like the same regularity and specificity; whenever they appear they do not always in any piano sonata or painting or building point to the same thing which they point to in some other sonata or painting or building. Thus the word *boy* always means "immature human male" or something closely related to that, but middle C can import fear or hope or calm or almost any organization of consciousness according to the other notes in the piece. The other distinctive property of language is syntax, the ordering of the words in a conventionally set pattern to eliminate ambiguity of reference. An example of syntax is the rule in modern English that in a sentence the actor normally comes before the verb and the acted-upon comes after. As a result of this rule of syntax the expressions *dog bites man* and *man bites dog* have different meanings. None of the arts has a comparable rule for combining elements. The effect of words and syntax is that language means *accretively*, by adding discrete bit to bit in linear fashion, whereas an artwork imports *cumulatively* by operating as a whole rather than a succession of parts. This is the main difference between discursive language and presentational art, a difference which we shall examine more closely later in this chapter. But we have seen enough already to reach some conclusions. One is that art is not a language. Another is that whereas language leads to that conscious knowing that we call truth (or falseness), art, lacking the attributes of language, serves different functions.

Art and Attention

Now we can examine some functions which art really possesses and which also have a place in basic education. One such function is attention. When we defined artistic experience earlier, we said that it is a state in which an object takes command of the attention, intensifying, prolonging, and shaping it. A concrete exemplification of this effect is the behavior of an audience at a well played concert, where a striking evidence of their fixation on the music, the artwork, is their temporary inability to make the polite response of clapping when the music ends. They applaud, but only after a delay, and generally the more powerfully the music has affected them, the longer they hesitate before applauding. Why that delay? The reason is that the audience has been so taken over by the music, so absorbed into the artwork, as to need several seconds in extreme cases to get back into the ordinary world and do the proper thing, applaud. Obviously the audience's attention, its capacity to give its whole mind to a thing, was abnormally increased during that time when it listened to the music. Art has this same effect on the young and even on the very young. One sees it, for instance, in the almost hypnotic preoccupation with which infants attend to the sheer aesthetic qualities of the mobiles and dolls that adorn their cribs.

Here is an instance of heightened attention at an in-school concert. The performing group was Los Caribes, a small band presenting Caribbean music; the place was the Newfane Elementary School, about twenty miles east of Niagara Falls, New York; and the audience was three hundred children ranging from kindergarten through third grade. The children filed into the gymnasium-auditorium without any fuss and, with no appearance of discomfort, sank down onto little mats that they had brought with them, crossing their legs beneath them, and sitting on their heels as gravely as Indian chiefs. I went to this concert particularly to see if I could discover whether or not children pay attention to performances, and I thought that the best way to find out was to look closely for any signs of inattention. I sat in a chair midway down the side of the room, a good position to observe everyone. Out of three hundred small children, here is the total amount of inattention during a forty-five minute performance: one girl left the room and did not return; one boy twice turned around to look behind him; a girl and a boy stretched out their hands towards their teacher and smiled delightedly when she noticed them. And that is all. No one passed notes, or exchanged glances, or whispered, or nudged, or shifted about. Apart from the exceptions just noted, three hundred children were riveted to a performance for forty-five minutes. What would teachers give to get that same concentration from children when they are in class!

Some studies claim that students who participate in aesthetic education programs succeed in academic subjects at a higher level than stu-

dents who do not have access to the arts.[4] These studies do not have rig-
orously correct controls, but if their findings are confirmed I suspect that
the reason will have something to do with the power of art to elicit intense
attention. I do not mean that art teaches attention in the sense that people
who have applied themselves closely in apprehending an artwork then go
on and automatically adopt the same attitude when they study the tradi-
tional academic subjects. Obviously they do no such thing. Learning is
commonly quite specific to the situation in which it occurs, and as a result
a skill that a student learns in one subject may not transfer readily to an-
other subject. A student who has studied equations in math class, for in-
stance, may need a good deal of prompting to work equations in chemistry
class when the application of the mathematics is only a little different. So I
think that any direct transference of attentiveness from art to academics is
unlikely. It is more probable that through frequently repeated artistic ex-
perience children get a clear impression of what attentiveness is and, once
they have undergone it themselves, they incorporate it in their repertoire of
potential behavior. Then, confronted with a difficulty in some purely cog-
nitive problem, they resort to this tactic learned in the other field, solve the
cognitive problem, and thus discover the value of attention in all mental
life, not just in art experience.

Art and the Integration of Mental Capacities

Whenever we successfully undergo an experience of art we feel an
almost unforgettable impression of wholeness, a wholeness between the
self and the artwork that is being contemplated and also a wholeness
within the personality itself when it is under the sway of the artwork. Both
kinds of wholeness also arise in other forms of attending, particularly in na-
ture study and in mystical religious experience, but in art the sense of
wholeness is more open to investigation since it results from a more certain
and controlled stimulus. In the late eighteenth century Friedrich Schiller,
the German poet and philosopher, searchingly examined this sense of
wholeness in a book that he called *On the Aesthetic Education of Man*.[5]
Schiller called this wholeness *freedom*, a word which he used probably to
signalize the important intellectual and ethical benefits which the condi-
tion imparts. For Schiller this wholeness or freedom is a middle state be-
tween the polarities of human intelligence: on the one hand pure sensation,
complete immersion in the sensuous qualities of an object, and at the op-
posite extreme, pure ideation, total abandonment to generalities and ab-
straction. The glutton, the drunkard, and the lecher might represent the one
extreme and the spaced-out dreamer the other. Of course there is not much
to choose between the sensualist and the airhead; we would rather not be
either. The discipline that gets rid of the bad in these two extremes and
unites the good, Schiller thinks, is our aesthetic experience. That experi-
ence holds together the two parts of our minds which would otherwise
divide: the sensuous part which knows things in their particularity and the

abstracting part which knows things in their generality, their relation to other things.[6]

The power of art to teach people to merge sensation and intellection in a single act of consciousness is best illustrated by the popular view of love. Clearly our ideas and expectations about love and the relations of the sexes mainly stem from art. The person who said that modern love is the sonnets of Shakespeare basically was right, although the statement is a little abbreviated. The fact of the matter is that modern romantic love—whether exemplified in a pair of teenagers squirming in a sub-compact or the grander couplings of Hollywood fertility gods—originated in art and still is nourished by art. The inventors were the medieval courtly poets, the troubadours, who confounded the natural physical attraction of the sexes with the religious love of the divinity by having each member of the human couple take the other not as a fellow human but rather as a divine object worthy of veneration.[7] These troubadours contributed the romantic love theme to the Arthurian romances, very popular tales which carried all over Europe the new idea of the human beloved as a divine being. Dante and Petrarch, Shakespeare and the other Elizabethans elaborated the deification of the loved one, and Wagner, working from medieval material, with his operas brought it into the nineteenth century. The idea motivated countless plays, novels, poems, operas, statues, pictures, and ballets. The popular artists caught it from their more distinguished brethren, and to this day they keep the ideal of romantic love fresh in our minds in soap operas and love ballads and even in comic songs.The love that men and women feel for each other today, at least in the West, is an artistic invention sustained even now by popular art. Nature does not dictate romantic love, and no trace of it appears among the ancient Hebrews or the ancient Greeks. In the Bible the highest form of love between the sexes is mutual honoring, as with Ruth and Boaz or Sarah and Abraham. Plato treats the love of one human for another as either an affliction or an almost shameful joke, something that a truly good person will ultimately transcend. The existence of modern love, this peculiar blend of natural sexual attraction with a learned religious attitude to the beloved, and its dependence on art as its source and sustenance, persuasively illustrates Schiller's notion that the aesthetic harmonizes the discordant impulses of the sensing and the thinking parts of our nature.

Art and the Elaboration of Consciousness

Here are three questions that students at different grade levels and in different classes might be asked.

The train depots in Chicago and Milwaukee are exactly ninety-five miles distant from each other. A passenger train, the Chicago Comet, travels non-stop from Chicago to Milwaukee in precisely one hour

and twenty minutes. Another passenger train, the Milwaukee Missile, goes in the opposite direction and on a track parallel to the Comet's at an average speed of eighty miles an hour, but the Missile makes a ten minute stop in Kenosha, Wisconsin. Which train covers the total distance between Chicago and Milwaukee more quickly?

Some writers have claimed that the war in Vietnam was lost on the home front. What do they mean by that claim, and how could they prove their contention?

Assume that one student knows for a certainty that another student habitually uses cocaine. Should the one student inform on the other to school officials?

These are hard questions. But questions that are just beyond the capacity of students to solve can greatly advance instruction if teachers provide the crucial help for their solution at the moment when the students need it. In the case of these questions what would that help be? Supposing that the first question would arise in a middle school mathematics class, the students might need help in sorting out the information that is necessary to solve the problem (the distance between the two depots for instance) from that which is unnecessary (the fact that the two trains go in opposite directions). Second, they might need to see that the speed of the trains is stated in different formulas but that either formula can be restated in terms of the other. Third, they might need a formula for multiplying the figure of average speed by the figure of distance traveled. What is mainly needed to deal responsibly with the second question is a conception of cause, specifically an idea of what historians are willing to accept as evidence that one event led to another event. Moreover, the students will need to clarify terms in order to make single, clear, unprejudiced propositions. For instance, they will need to understand that the United States did not "lose" the Vietnam War in the same sense that Japan lost World War II. To deal with the third problem, a question concerning ethics, students will have to command the overall shape of a deductive argument. At a minimum they will need to identify moral axioms, show that premises really entail conclusions, answer contradicting arguments. Depending on the students' maturity and the goals of instruction, their preparation for dealing with this question might go as far as the study of formal logic—rules for testing the validity of syllogisms, construction of sorites, criteria of essentialist definitions.

All this might be called the "outside" of problem solving, the intellectual methods that are specific to mathematical reasoning, historical thought, or ethical argument—strategies that are definite, describable, teachable. But there is also an "inside," a characteristic stance of consciousness when the mind adapts itself to deal with the peculiarities of any particular problem. Notice, for instance, that in addressing the mathematical problem the mind restricts itself pretty much to what is there in the stated

situation and adds to that situation only a system for classifying the information about speed and a formula of computation whereas in treating the ethical problem the mind expands the stated situation by importing material not originally given, such material, for instance, as an estimation of the duties imposed by friendship, or a comparison of the varying degree of harmfulness of different illegal drugs, or a recognition of the different laws concerning drug abuse. So when our minds are active they follow "outside" laws that are dictated by the nature of the object being studied, but they also obey "inside" laws that express the operation of one particular mind itself as it works in some one of innumerable possible ways to deal with one of an infinite variety of potential situations.

Another example will make clearer this distinction between the "outside" of consciousness and the "inside," and it will also go a good way to show that in fact the two sides of consciousness really do exist. The case of "Little Hans," which is among Freud's best known diagnoses, typifies the psychoanalytic method of study.[8] The young boy Hans had been brought to Freud for treatment because he suffered from a recurrent nightmare of being bitten by a horse. Freud helped Hans arrange the other data of consciousness around this dream, both additional "inside" data about Hans's other mental phenomena—his free associations and other dreams of his—and also the "outside" information about real episodes in Hans's earlier life and his current situation. Once all these data fell into place, Hans and Freud began to comprehend Hans's condition. One crucial datum was that Hans's father had taken fairly drastic steps to get Hans not to masturbate. This action had intensified Hans's insecurity, and he began to feel that his father was going to castrate him. The whole complex of Hans's thought and feeling was like being bitten by a horse, which became the symbol expressing Hans's particular sentience, the "inside" of this one stance of consciousness.

With their extreme lability, their capacity to take on many more shapes, dimensions, and nuances than we can state or even recall in our waking moments, dreams are the perfect expression of the "inside" of any person's consciousness at any particular time. But dreams are not the only index to the inside of sentience. Art is another, and in its generality it has an important advantage over dream. Dreams are solipsistic and irrational things, but the fantasies of art, more public and stable than dream, are already tending towards reason. Hans's dream, like anyone's, basically is private; it is an appearance exactly projecting Hans's very own stance of sentience at the time that the dream occurred. But an artwork is not a sign of *someone's* sentience; instead it is an expression of a consciousness which *anyone* can contemplate once that expression of it has been grasped. This point needs to be made explicit since the obvious expressiveness of art is often assumed to be self-expression. But an artwork does not necessarily express the maker's frame of mind at the time the artist fashioned it. We can see the truth of this assertion when we consider such a work as Tchaikovsky's Sixth Symphony, the *Pathétique*. If Tchaikovsky

had been prey to the deep despondency represented by that work, particularly the outer movements, he could not possibly have been in a state to do any composing whatever, and the symphony never would have been written. Similarly, Milton's *Samson Agonistes* expresses in its final moments and in its culminating line—"All calm within, all passion spent"—a state of sentience totally at odds with the act of creation.

Now the significance of our terms "outside" and "inside" is becoming clear. Those words really point to two different kinds of reference. In our analysis of the questions that might be posed to students, when we spoke of the "outside" of sentience we meant the students' awareness of the palpably observable: in the first question such a fact as that trains run between Chicago and Milwaukee, in the second question the fact that the United States fought a military action in Vietnam, in the third question the fact that some students use illegal substances. And when we spoke of the "inside" of sentience we had in mind the students' awareness of particular mental states—intellectual, emotional, attitudinal, sensory—and also all the immense number of possible blendings of these varieties of sentience. The symbols that minister to the mind as it looks outside to deal with the world, to identify all its parts for what they really are, to see the relations of those parts to each other and to ourselves, are *discourse*. The symbols through which the mind looks inside to inventory and expand its own modes of operation and its countless available envisagements of possibilities of existence in the world are *presentation*. The capital form of discourse is language other than literary; the capital form of presentation is the arts. Literature, a sort of link between the two symbolisms, is mainly presentational (as projecting forms of consciousness) but also usually contains a strand of discourse (as indicating actual conditions in the real world).

This is not a distinction between hard-headed realism and vaporish feeling. Both mental actions will have to take place before genuine knowing can occur, for discursive understanding presupposes an underpinning of presentation. In order to answer the questions posed at the beginning of this section, students would have to undergo presentational activities to prepare their minds for recognition of certain facts. For instance, answering the second question obviously requires a conception of cause, for the debate reflected in that question essentially is about what caused the United States to withdraw its military forces from South Vietnam. Now cause is a highly abstract conception, and it is never visible. This little dramatic monologue will illustrate the point: "(1) Here comes an old lady. (2) And here comes a boy running towards her. (3) Oh, that naughty boy! He knocked her down!" Speakers of such a monologue would be willing to claim, probably under oath even, that they really *saw* the boy knock the old lady down, that is, cause her to fall. But a little analysis shows that they *saw* no such thing. What they saw was a sequence of frames. In the first frame an old woman approaches, and in the second a boy. Frames three and four do not show the boy knocking the old lady down; they show the two bodies in contact in frame three and then in

frame four the old lady lying prone. Frame four might not have resulted from frame three at all. It could have come about because the old lady suffered a heart attack just a second before the boy pushed her. Or it may even have been that the boy sensed her faintness and tried to hold her up but was too weak to do so. Ingenious interpreters can think up still other explanations. So we do not "see" cause; all we "see" is a sequence of events, and cause is a thing that we attribute to the sequence, a conception springing purely from the mind and embodied for the mind in presentational images. The same is true of the conceptions of time and space which are indispensable in solving the problem concerning the two trains. Time and space are invisible and impalpable, so we never see them or feel them in the world. Instead we experience them presentationally in the virtualities of art and the other attending experiences which are both early and continuing exercises in life envisagement.

At one point in this discussion I was tempted to use the word *objective* to correlate with what I have called "outside" data and *subjective* to pair with "inside" data. At first those more familiar words seemed to clarify my ideas. But I had to reject them nonetheless, for in the end they obscure the fact that our confident notion of the world as a palpable construction in space and time within which events happen intelligibly as observed results of foregoing events is not objective at all in the sense that it is based purely on "outside" data. Instead it is a product of processes internal to the mind itself, processes which are learned by being projected to us in experiences of attending but most powerfully and clearly in our experiences of artworks.

FOOTNOTES

[1]A comprehensive and thorough discussion of recent writing on the uses of art is Ralph A. Smith, *The Sense of Art: A Study in Aesthetic Education* (New York and London: Routledge & Kegan Paul, 1989).

[2]I. A. Richards, *Principles of Literary Criticism* (New York: Harcourt, Brace, 1952).

[3]Harry S. Broudy, *The Uses of Schooling* (New York: Routledge & Kegan Paul, 1988). Broudy's conception of the "allusionary base" of thought gives to general or basic education, including aesthetic education, a much clearer and more active role in mental life than is commonly assigned it.

[4]An article entitled "Imagination Celebrations Link the Arts and Education" in *New York Teacher* 32 (25 June 1990): 20, quotes a teacher, Karen Traverse, as saying, "'With a social studies grant, we proved, statistically, that kids improved scholastically through using arts formats in education.'"

[5]Friedrich von Schiller, *Letters on the Aesthetic Education of Man*, trans. Reginald Snell (New Haven: Yale University Press, 1954).

[6]George Santayana, in *Reason in Art*. Vol. 4 of *The Life of Reason*. (1905; rpt. New York: Dover Publications, 1982), 15, restated Schiller's view with a concision and grace that are characteristic. "Between sensation and abstract discourse lies a region of deployed sensibility or synthetic representation, a region where more is seen at arm's length than at any one moment could be felt at close quarters, and yet where the remote parts of experience, which discourse reaches only through symbols, are recovered and recomposed in something like their native colours and experienced relations. This region, called imagination, has pleasures more airy and luminous than those of sense, more massive and rapturous than those of intelligence."

[7]The development of the idea of romantic love in the Middle Ages and Renaissance is recounted in C. S. Lewis's *The Allegory of Love: A Study in Medieval Tradition* (London: Oxford University Press, 1936 and frequently reprinted).

[8]This case is studied in Peter Gay's *Freud: A Life for Our Times* (New York: Norton, 1988), 255-261.

CHAPTER THREE

Katie and the Arts

An extended example using my young friend Katie will clarify some of the ideas that have been presented so far and also some that will appear in the next two chapters. Although Katie now lives in Maryland, during the greater part of the period surveyed in this chapter she lived in Fort Worth, Texas. In the first four-and-a-half years of her life I was a house guest in her home on five different occasions, each visit lasting from seven to ten days. My visits to Fort Worth occurred when Katie was just under nine months, then at a year and seven months, at two years and seven months, at three years and seven months, and at four years and eight months. These are almost regular intervals, and since I only saw Katie at those times, I could easily note the main outlines of her development and was not thrown off by daily and weekly variations.

Nine Months

At nine months Katie was physically very close to the average, different only in being slightly under normal weight. The toys in which she showed most interest were the wooden spools attached to her stroller, which she would hammer with her fists and watch as they turned, the pretty bird mobile in her bedroom, and, in her play pen (where she already did not like to stay), many wooden blocks and plastic objects which she would turn about in her hands and feel with her hands and lips. As for locomotion, she could pull herself up on furniture and then stagger along for a short distance. She was just on the point of crawling, and indeed within a few days of the time I left she was crawling easily, but when I was there she still had not mastered it, and although with a good deal of random kicking and pushing she could go backwards, she had no luck at all going forwards. At just nine months, then, she was practically immobile but giving signs that she would soon remedy that handicap.

Her linguistic development seemed to be on a level with her capacity for movement; she was getting ready to function but was not yet functioning. For instance, she certainly did hear language, watching and listening intently whenever we talked to her. Moreover, she had entered the lalling stage and was producing long streams of highly varied sounds in-

flected with junctures and pitches. Just when I left we thought we had detected her using her first word—*da*—but decided the sound was only accidental and not really applied to her father. Soon after, however, she did have words for both her mother and her father, and then she went on quickly to master many more words. The main fact about her mental development at this time was that she could *attend*, observe closely, even passionately, but she could not *intend*, could not yet decide to do this or that, go here or there. Essentially she was passive, not active, and her little life was full of impact but devoid of action.

A Year and Seven Months

At a year and seven months Katie had advanced far beyond her previous level. She still cherished some of her toys from the earlier time, but her dolls now seemed to have more personality for her than formerly (she talked to them as if they had lives of their own), and she had many books, the stories of which she could recall by the pictures. What seemed to be of greater interest to her, however, was music, rhythm in particular. She would listen enchanted to her records. Once when a waltz was playing I picked her up and danced her around the living room. She was delighted, and she beamed every time the emphatic *one* came in the sequence of *one*-two-three, *one*-two-three. Another incident also illustrates her delight in rhythm. She knew the "Pat-a-cake" nursery rhyme and the little gestures that go with it. When I recited it to her, keeping the familiar emphasis but doubling the tempo, she was enthralled by the new pattern and wanted the performance repeated again and again. She was attending to everything with greater earnestness than formerly and with more deliberation.

Her problems with locomotion were almost over. Not only could she walk and run, but she would also go fearlessly into the adult swimming pool with her mother or me and gladly submit to being pushed about in the water. She was still too young to be careful in her walking and running, and once she had a bad fall. This incident revealed what a distance she still had to go before she could make much communicative use of language. After her fall she cried loudly and was not consoled, as she usually was, by my attention. She wanted her mother, and in spite of all the petting she received from the two of us, she remained fretful. Katie could not move one of her arms, and when we tried to move it for her even gently, she cried out in pain. After an hour passed with no improvement, Katie's mother took her to the hospital for treatment. There Katie's arm was x-rayed, and of course Katie cried again when it was manipulated. But then, surprisingly, the pain disappeared and Katie could move her arm. All this seemed to happen spontaneously, for the x-ray showed no abnormality and the doctor had not given any treatment. During this episode Katie could not use language to help herself. Partly her inability may have resulted from stress, but the primary reason was simply that her linguistic development had not

gone far enough. She could produce one-word and two-word declarative sentences about the things around her, and she could also ask simple questions, mainly by vocal inflection rather than any structural change in the sentence. But mood, tense, and the other nuances of language were beyond her. As a *receptive* tool language was already valuable to Katie, but it was not yet working efficiently for her as a *productive* tool.

Two Years and Seven Months

Just a year later, at two years and seven months, Katie had advanced much farther. Some of her older toys were still dear to her, particularly the dolls and books, and she also added altogether new recreations. She had already been attracted by music of course, but now her interest in her old records and her new ones went beyond rhythm, and she listened for narrative and lyric values which she had not noticed before. In all the developments that I saw on this visit Katie seemed to be moving towards a primary interest in life-envisagements, however fanciful, and away from attending to pure sensuous qualities—such things as shape, size, weight, texture, color—that had formerly been sufficient in themselves to delight her. Puzzles were a completely new and intense interest. The size of an ordinary sheet of typing paper, made of heavy cardboard and cut into anywhere from seven to sixteen pieces, these puzzles depicted characters and scenes from such stories as "Snow White," "The Three Bears," and "Sesame Street." Katie had perhaps a dozen of these at the time, and later she acquired more, for they utterly absorbed her, holding her undivided attention for a half hour at a time or longer. She dwelt almost obsessively on each of the different art objects, both records and puzzles, repeatedly going back to each one and experiencing it over and over until it became totally familiar. Katie had also developed a liking for television, which had not interested her a year before. Now she liked the children's programs, and "Sesame Street" in particular was a favorite. She could tell me all about Big Bird, the Cookie Monster, and the others. A traveling theater production which came to Fort Worth had introduced her to the story, and afterwards she followed it closely on television, in children's books, records, and puzzles. In addition, Fort Worth has a restaurant designed especially for children, and this restaurant features an elaborate Sesame Street show of puppets—bear, ape, and others—that play instruments and sing. Almost as soon as I came off the airplane, Katie made it clear that she wanted to go to this wonderful place. Once there, Katie was lost in that fevered fascination that aesthetic objects still produced in her. She scarcely noticed her parents or me as long as we remained there, and she was reluctant to leave.

The fact that Katie said she wanted to eat at a particular restaurant was a measure of how far her language had developed in the previous year. On my earlier visit she was not capable of making such a statement.

At that time she could manage short declarative sentences, but she could not assert that she wanted to do such-and-such a thing. Now she could, and as a result of this language acquisition Katie was in the full bloom of the "terrible two's." What makes them terrible, I suppose, is that a baby rapidly becomes a person. The child is no longer just reacting to things; it is also acting upon them, not always with good judgment of course. So Katie's language reflected this new status of personality as it really enters the world and acts upon it. Katie was asking questions, answering questions, and making assertions. She even gave me a plain command. At one end of the living room were two rocking chairs, and Katie went to sleep more readily if she was rocked in one of them. Katie had few baby words, but she had made up one for "rock"; it was "gie." When I offered to rock her to sleep she told me, "You gie yourself. Mommy will gie me." Those sentences are correctly quoted, including the reflexive and the tenses. With a functional grammar and a good size vocabulary, Katie communicated factual material easily, telling stories about her activities in the preschool she attended, expressing her wants, asking for information.

This greatly increased power of language had sharpened Katie's intelligence to the point that it was now a mind. Words had given her memory. I was not any more just a casual, inexplicable presence. Now I was someone for Katie—Bruce—and I came from far-off Buffalo in an airplane. Words had given her associations that individuated people. Quite of her own accord Katie had assigned different colors to the people who mattered to her. Her grandmother was pink; I was green. Her mother was red, her father blue. Her aunt was purple, and her most usual baby sitter was orange. Katie herself was yellow. Every new identification and association made Katie's experience richer and more definite, more closely tied both with the realities of this world and the bent of her own growing mind.

Three Years and Seven Months

I next saw Katie when she was three years and seven months old. Over the intervening year she had grown considerably in linguistic and intellectual capacity. In addition, the tenor of her art life had continued to change. She was now even less interested than formerly in the pure sensuous surface of art objects. This decline of interest in appearance showed in the perfunctory way that she now dealt with her puzzles. Although she still kept them, she only played with them when I suggested it. And rhythm in music or in poetry did not enthrall her as before. When I repeated the old variations in speed while reciting the "Pat-a-cake" rhyme, she was interested, but she showed none of the delight, the loss of self in the rhythm, which was obvious two years earlier. Similarly, she did not now spontaneously create rhythms of her own in walking and speaking. She danced occasionally but not as often as formerly or with the old abandon.

Her decreased interest in shapes, colors, sounds, and tempos was offset, however, by a much greater attentiveness to the narrative element in stories, poems, and songs. She retained her earlier interest in "Sesame Street" and watched it avidly as well as the video cassettes for children which her parents rented. She followed story lines and character development closely, and she immediately caught the joke of a character who always larded her speech with a continual succession of such amiabilities as "Yes, please, thank you, ma'am." She had just begun to invent her own stories, highly derivative from her real-life experience and from the television programs and videos she had been watching. After her mother, father, and I went swimming with her, she told a story in which one of her dolls went for a swim, and once when she played with her Sesame Street figures, she imagined them going to church, to the doctor, and to the dentist, all activities which she had recently engaged in. She attended pre-school, and she was happy to play the role of teacher with me as student, but when I mischievously asked her why I should obey her she was not able to stay in her role or to answer the question. The best she could do was to repeat her former command and to outline the functions of teacher and student, which is not at all bad for a three-and-a-half year old but which certainly is neither sustained fiction nor logical thought.

This period seems to have marked a decline in Katie's earlier pronounced aesthetic curiosity. If she really was less rapt in the art objects that surrounded her, the explanation probably has to do with her beginning at this point the difficult transition in her mental life from pure fantasy to realistic thinking. She much more distinctly had a self now, and along with this expanding self, perhaps because of it, she was colliding with the real world of adults who occasionally corrected her and of other children who sometimes crossed her. Katie's just-begun negotiation with the real world at present diverted her energy from pursuit of the purely aesthetic. This new and disturbing awareness of reality may also have been the reason why her speech, though much richer in vocabulary and grammatical forms than before, was now often hesitant and uncertain. Even for a fortunate child like Katie—gifted with health, comfort, loving parents, security—the *business* of life begins early. Katie was trying to make her language match the world, which is a daunting task at any age. Problems that will later be refined for her as studies in epistemology and ethics were at this point crystallized as matters of conjugation, a linguistic operation of transmuting *is* into *can be*, *would be*, and, ultimately and terribly, *might have been*.

But Katie was rapidly acquiring linguistic capital. In this connection her most obvious advance beyond the previous year was that she had learned to print all the letters in upper case and the numbers as well. Her letters were well formed, indeed indistinguishable from adult printing, except that the curves in S, 0, and U gave her trouble so that she drew those letters much larger than the others. As she made an R she cleverly remarked that it was a line (I), a circle (P), and a foot (R). Without any help at

all with the spelling, she could correctly print her mother's name, her father's, mine, and several of her friends'. All this writing was perfectly voluntary; she did it both on her chalkboard and on paper apparently just for the pleasure of the activity rather than to gain praise. At this point, when she was learning to write only what she wanted, she restricted herself to the names of the people she knew; she showed no interest yet in common nouns or verbs and no desire to write sentences or even phrases.

In statements of fact, questions, requests, and commands Katie was fluent, easily carrying on conversation with adults and other children. She had learned the pattern of turn taking in talking with others, and she signaled that she wanted attention with the expression "Excuse me." Except for her old word for rock, "gie," she used no baby words, and in the indicative mood, whether past, present, or future, her talk was purposive, with none of the self-directed babbling of earlier times. But with the subjunctive mood and with narrative, especially imaginative story telling, Katie was much less articulate and communicative. In both these forms she was hesitant, her voice going up in pitch and her syntax becoming irregular. At this stage the words *if* and *because* would invariably lead to wandering or mere phatic mumbling; the words were usually unmeaning and indistinctly pronounced, sometimes not intelligible at all. Though perfectly adequate for reporting observable events, Katie's language was not yet suited to stating causal relations.

Katie's intellectual advance was in step with her aesthetic and linguistic behavior. Like any three-year-old, she was still preoccupied with herself. For instance, she used the expression "Excuse me" not to be genuinely considerate but rather to interrupt someone else's speech and to demand attention for herself. But although Katie was still in the ego-centered stage, the process of decentering had already begun. A touching instance of her beginning to turn outwards towards a richer consciousness of others was her making a special friend of Jess, a fellow student in her pre-school class. Each of these two spontaneously gave to the other as well as took. Other signs of this incipient decentering were Katie's increasingly accurate assessments of reality, which she showed a number of times just in the week that I stayed with her. In one instance she had lunch in a restaurant with her mother and me when a boy who seemed to be sixteen or seventeen came in with a girl his own age and a woman who appeared to be his mother. The boy used a crutch, and his right foot was in a plaster cast. Katie immediately drew the correct inference and said, "That boy has hurt himself."

How did Katie know that? The boy was not crying, the sign of physical hurt most familiar to her. At home she heard very little conversation about physical injury or sickness. In real life she had never before seen a cast on a person's foot. So where did she get the idea that the boy had hurt himself? It happens that in the day or two before this episode took place Katie and I played together. We watched a couple of videos which

showed the cheerful mayhem that occurs in much art for children; the physical injury is seen as more farcical than really painful. Later we played with her Sesame Street dolls. As I mentioned earlier, Katie imagined them visiting the dentist and the doctor. In fact it was the Cookie Monster, Burt, and Ernie who saw the dentist while Big Bird, with an injured foot, visited the doctor. So I am fairly confident that Katie made the inference about the boy's hurting himself on the basis of learning that she had acquired from art, first from watching this particular envisagement of life presented in the videos and then trying it out herself in the scenarios that she composed for her Sesame Street figures. In strict accuracy I should add that I do not recollect anyone's wearing a cast or even a large bandage in the cartoons that Katie and I watched. But from my general knowledge of these videos I know that such a spectacle is shown so often that Katie could hardly have missed it.

During my visit Katie made other responses to her surroundings which she probably first acquired from her art life. Children Katie's age concern themselves with the way others feel about them, with their relations to family and friends and the children they meet here and there. Katie's videos and her favorite television programs catered to this interest by focusing on personal relations, on the likings and dislikings of characters for each other, the adjustment to rejection, the interactions within a family circle. I saw Katie draw on this art experience when, eating in a McDonald's with me and a little girl friend of hers, she and her friend suddenly were confronted by a girl considerably taller than they who stood up on a bench, glared at them, and proclaimed, "I'm four. I'm bigger than you." Katie's shocked response was to look at me and say, "She doesn't love me." Katie was right, of course, and if anything she underestimated the girl's feeling. There is a lot of unfocused anger in the real world, and on this occasion, perhaps for the first time in her life, Katie was the target of it. Neither Katie's family life nor her carefully supervised experience in preschool and in other meetings with her friends had exposed her to undiluted hostility. Her somewhat softened recognition of it on this first emergence was based on the presentations of destructive emotions which she found in art.

Four Years and Eight Months

At the time of my next visit Katie was four years and eight months. Her physical growth had slowed a little, and she was still slightly less than average weight. She was very active, with much increased stamina. In motor skill she was close to the adult level except that she had less-than-adult strength in her arms and lacked dexterity in her fingers for such delicate manipulation as tying bows.

Artistically, Katie seemed to be in a period of concentration rather than advance. She had largely lost her interest in music, nonsense verse, and puzzles, and she had acquired no new aesthetic interests. On the other hand, she retained and perhaps even intensified her earlier liking for dolls and videos. What these two art forms have in common is obvious mimesis; they both plainly imitate life. But here is an anomaly. Katie was not in the least troubled that most of them were preposterously unrealistic. The videos, mostly about fairy tale characters and anthropomorphic animals, concerned nothing that Katie had ever witnessed, and her favorite doll, incongruously called Prince Philip, was an inflatable swimming pool float shaped like a rabbit eating a carrot.

Katie's engagement with the videos followed a pattern of increasing involvement through re-viewing. This behavior was unmistakable, and I observed it several times. She would watch a video negligently in her early sessions with it, going out of the room while it was playing, for instance, or moving about or starting up desultory conversation. Then gradually her concentration on the video would increase as she became more familiar with it. Thus, prolonged exposure to the same videos brought not boredom but intensified interest and closer scrutiny.

Katie's own artistic creativeness was also mainly dramatic, the making of playlets that derived almost immediately from real life experience. For instance, she and her parents had recently visited relatives in Washington, D. C., where they attended a wedding, and a game that she liked to play with me was staging a marriage. The casting was bizarre. Katie was the bride; the groom was the afore-mentioned Prince Philip; the clergyman was her rocking horse; and I was a "pink," a bridesmaid. The unrealism which Katie so readily accepted in her dolls and videos was also reflected in her own unregulated fantasy in setting up these little plays. She seemed to make no connection between the world as it really exists and what went on in her head as projected by the artworks which she either constituted through attending or herself made. It was as if she were preoccupied with extending her own mental operations before trying to connect them with the real world.

In holding steady at about the same level of aesthetic development which she had attained the year before, Katie seemed to me to be withdrawing her energy from one dimension of intellectual growth in order to make really extraordinary advances in the two other dimensions of language and reason. She was now using oral English that scarcely varied at all from the standard dialect, and she possessed the resources of vocabulary and grammar to express herself fluently. She no longer filled up grammatical conditionals with a mere buzz; rather she went right ahead to make perfectly intelligible sentences. Her very few departures from correctness which I noted, all of them false analogies, were themselves evidence of a growing linguistic inventiveness and command. Katie had not yet learned the irregular superlative of *good—best—*but instead said *goodest*, and in

tense formation she consistently used the weak verb form so that she said *beginned* rather than *began*. But even these non-standard usages, mere temporary aberrations of performance, arose from regular and conscious application of true grammatical principles.

This imposition of logic on irregularities of grammatical convention, though inappropriate in the instances given here, indicates that Katie's power of reason was also rapidly increasing. There were other signs too, best illustrated by the remark she made concerning my objection to her unrealistic casting of the wedding—"It's all right. We're *pretending*." That speech is an argument in the technical sense. More exactly, it is an enthymeme, a sort of stripped down syllogism that omits one of the premises. "It's all right" is the conclusion, and "We're *pretending*" the minor premise of a syllogism which, to be complete, would need the sentence "Pretending is all right" as its major premise. I do not claim that Katie at this tender age was a logician, and certainly during this visit I disagreed with a good number of her conclusions. But from the perspective of this book the important thing is that Katie was inventing genuine arguments. She had already become a reasoning human being. With more experience of art, language, and the world she will advance much farther intellectually. And if the pattern of her development remains what it has been, then art will lead the way.

Postscript: Six Years and One Month

I had intended to finish the present chapter at this point where Katie had rounded out a full stage of her development of mind and personality. But since then in one striking incident she has used art in such an entirely new way and with such a successful outcome that I feel I should recount this one episode from the next phase of her growth through art.

Not long after the visit I have just described, Katie moved with her mother and father to Maryland, the Washington-Baltimore region. The move corresponded with her beginning to attend regular school, and it was in November of the year Katie entered first grade that she and I created an artwork which had a definite effect on her life in school. At this time she was six years and one month old. I had been attending a convention in Baltimore and was able to spend a few days with Katie and her family. At the same time Katie was at home with a sore throat, and then the Thanksgiving recess gave her a couple extra days. I learned that although she was succeeding very well with her subjects, she had begun to show some disliking for school. She never had any specific important complaint when she returned home, but some mornings she would try that childish expedient for avoiding school, "Mommy, I don't feel good."

When Katie and I got together, we tried out first one activity and then another, but rather quickly we settled into the making of a little drama. Our skit referred to a procedure for buying milk at school, which Katie so far had not dared to attempt, preferring instead to bring her own milk with her in her lunch pail. At school the children had to buy milk by standing in line and then, one by one, walking up to a man, who was not Katie's regular teacher, handing him twenty-five cents and asking for chocolate milk or white, which he would then give them. Katie entered into this skit in a serious way, and we enacted it again and again, changing back and forth the two roles of milk distributor and of Katie herself. Every detail was punctiliously observed. Although one person cannot, alone, stand in single file, even this feature was accounted for verbally, and we were realistic in keeping a distance of four or five paces between the teacher and the first child in the line. The simple dialogue never varied and was clearly enunciated. "What kind of milk would you like, Katie?" "I'd like chocolate milk, please. Here is my quarter." "Thank you, Katie." "Thank you, Mr. Blank."

Immediately after the Thanksgiving holiday Katie began buying her milk rather than bringing it with her, and she no longer attempted to avoid going to school.

I do not want to be melodramatic and claim that a deep childhood trauma was cured by a small dose of art therapy. For one thing, Katie was not traumatized by school; she was only frustrated by it. After all, I am a great deal older than Katie, I am a confirmed academic, and some mornings I also hate going to school. The feeling is so normal that it can be explained without resort to depth psychology. Second, what Katie and I did may well have been therapeutic, but it certainly was not art therapy as the term is generally understood. We were not getting in touch with our emotions or recalling repressed desires. On the other hand, neither should this episode be dismissed as of no account in Katie's development. She really had been reluctant to go to school. Moreover, although it is not possible to prove that the playing out of the drama was the means through which Katie surmounted her disinclination for school, still the sequence of events strongly suggests that the artwork did have something to do with the change from Katie's resistance to school in one week, her making up the play with me in the following week, and then her acceptance of school in the third week. What happened, I think, is that the play formulated and thus objectified the situation for Katie. It abstracted one circumstance from the complex and extremely interesting flow of life, emptying that circumstance of immediately felt emotion and therefore of the significance which Katie had attributed to it. The play showed Katie that buying milk is not inherently threatening. By bringing the affair into consciousness while at the same time excluding it from practical action, the play made the episode purely a thing of the mind, and at that level Katie could see that buying milk is a trivial action, hardly worth worrying about. In setting a thing in

our minds for steady, deliberate contemplation, art may rid us of many a bugaboo.

This study of Katie, which in its main points resembles the outlines of development of most children, vindicates the primacy of art in the life of the mind. Art holds the primacy not because it is the highest mental act but rather because it is the first, the original step in the ascent to reason.

CHAPTER FOUR

Good Art and Bad Art

A Bad Art Form

If the experience of art is what the first chapter says it is, and if the experience does for us what the second says it does, can there be such a thing as bad art? Before putting a substantial amount of art into our schools or our homes we ought to deal with this question, for we no more want to give children bad art (if such a thing exists) than we want to give them false science or unhealthy physical education.

I think that bad art really does exist, abundantly in fact, and I am going to illustrate it with a form which can be seen on almost every commercial television station at least once on weekends, sometimes more than once.[1] It is professional wrestling, which, an altogether different thing from the honorable high school and collegiate sport of wrestling, is a bona fide though degraded art form.[2] We can see that it is art rather than sport when we consider how carefully arranged it is in comparison with the much more open and free-flowing sport of wrestling that is practiced in the schools.

More often than not a professional wrestling match will pit against each other two performers who are almost direct opposites in looks, behavior, and apparent moral character. The protagonist is young, beefily good-looking, and well behaved in a somewhat milksop fashion, and the antagonist usually is old, ugly, and vicious. Normally the ring announcer will first introduce the handsome young hero, who bounds into the ring, gracefully acknowledges his supporters' enthusiastic accolades, and, pacing the ring excitedly and slapping himself vigorously on the chest and biceps, impatiently awaits the arrival of his dreadful opponent. The villain enters with commotion, which he instigates with some such indecency as giving a Nazi salute or drooling disgustingly or screaming unintelligible but presumably hideous imprecations. Unless he is lucky enough to be naturally deformed, he will deck himself out in a disfiguring mask and a garish costume. Sometimes the villain wears clumsy sheepskin boots, and he may heighten the bizarre effect by shaving his head or donning fantastically decorated tights. Other paraphernalia that plainly identify the villain are snakes, whips, chains, branding irons, and (yes) a woman's feather boa. The match itself may begin in the regular way with the ringing of the bell, but it is just as likely that the villain will make an unannounced and ferocious on-

slaught against the hero, who, all unaware, is removing his jacket or exercising or just meditating. This violent attack surprises the hero and puts him at a serious disadvantage for the greater part of the event. The villain mercilessly subjects the hero to the most punishing maneuvers, violently throwing his head against the turnbuckles at the four corners of the ring, dragging his face along the topmost rope, gouging his eyes, kicking him in the gonads. With all the mayhem it is no wonder that the hero suffers considerable injury, and one doubts whether he will carry on at all when, for example, the villain twists his arms and legs or throws him out of the ring onto the concrete floor. Nonetheless, the hero suddenly recovers his strength and delivers some terrific blows or else, rebounding off the ropes, propels himself against his opponent and pins him, thrashing and howling, upon the mat. With almost no warning at all, the match is over, the villain skulks away, and the hero, amidst the plaudits of his fans, modestly retires to the dressing room.

In this bare summary we see that professional wrestling really is an art form, setting itself apart from the quotidian mess and standing alone as *an* experience. It arrests the attention and prolongs and controls it in the ways characteristic of the other art forms to which it is most closely allied: circus, dance, pageant, and drama. Like circus, it highlights the action by making it more conspicuous than the surroundings, achieving this end by the cunning use of lighting, sets (i. e., the central position of the ring, its physical separation from the audience), costumes, and ceremonial procession. Like dancing, wrestling is choreographed so that the performers express a realm of power that greatly exceeds the amount of force which human bodies really can exert. Like pageant, it features the spectacular and eschews detailed realism. Like drama, wrestling opposes its characters against each other, and also like drama it achieves striking effects by showing sudden reversals either in the characters' fortunes or their personality and behavior.

Examination of these reversals will show the reason why professional wrestling is bad art. The reversal which wrestling most often exhibits is the unexpected and unlikely triumph of the heroic underdog over the villain, who up to the climactic turning-point near the end has had the match all his own way. Wrestling also has another kind of reversal, the sudden and inexplicable conversion of good guy to bad guy, a conversion in which the decent hero will all at once and for no apparent reason be transformed into villain. (More rarely, the villain may reform and become a hero.) Sometimes this transformation has to be supposed to take place between matches, but a more excitingly dramatic presentation is for the change to happen right before our eyes *inside* a match.

For contrast consider the reversal in Shelley's epic drama *Prometheus Unbound*, "epic" both in the sense that it borrows material from this form of heroic literature but "epic" also in the grand scope of its action. Shelley's play carries on the plot of the ancient Greek drama,

Aeschylus' *Prometheus Bound*, but Shelley makes a considerable change from the earlier work. Whereas Aeschylus portrays the god Zeus as merely dominant and somewhat arbitrary and Prometheus as generous and brave but almost insolently stubborn, Shelley makes the characters morally opposite; Zeus is a selfish tyrant, both cruel and cowardly, implacable enemy to human kind, and Prometheus is the high-minded hero who, by withholding the secret of the manner of Zeus's eventual downfall, protects the human race from extinction. Thus, Shelley simplifies the conflict as it exists in Aeschylus' play, making it a straightforward contest between the power of merciless oppression on the one hand and of freedom-loving defiance on the other. But then in the first act there is a reversal in the personality of Prometheus which greatly complicates the initially simple conflict.

Prometheus has told his mother, the Earth, that, after being overcome and horribly tortured by Zeus, Prometheus cursed his great tormentor with a prediction of Zeus's overthrow. Exultantly revengeful, the Earth and Prometheus together call up from the misty underworld of specters the phantasm of Zeus and cause it to repeat the curse, and a ferocious malediction it is. (Act I, lines 262-301) It is a moment of "getting even," a forbidden pleasure that few of us can easily forego. Shelley himself was an enthusiastic hater, and such poems as "England in 1819," a scurrilous attack on the royal family, and *Swellfoot the Tyrant*, a diatribe against George IV, illustrate his talent for invective. Up to this point Shelley has managed his drama in the same way that a professional wrestling bout is arranged. That is, he has presented us with one character who is altogether good (Prometheus) and one who is completely bad (Zeus); the bad character wins an early advantage and reveals his nastiness; handicapped by his own decency, the good character fails to defend himself effectively; we in the audience begin to despair. What should happen here, if Shelley follows the model of wrestling and other melodramas, is a sudden turn-around: the bad guy, predominant until now, should suddenly be bested by the good guy; Zeus should lose to Prometheus. Or, if we are not yet to have the satisfaction of Zeus's fall, at least we should be reassured that Prometheus is still enraged, that Zeus will eventually lose and endure a terrible humiliation. But then, prepared as we are for the delicious pleasure of hating in a thoroughly good cause, we get a shock of disappointment. Prometheus regrets his curse and even, in effect, renounces it:

> Grief for awhile is blind, and so was mine.
> I wish no living thing to suffer pain.
> (I, 304-305)

Here is a difference indeed from the polarity of good versus bad which imbues professional wrestling! The mental state embodied in the wrestling match is a simple contradiction between two perfectly balanced opposites. The hero is entirely good, with no hint of shortcoming, and the villain, as fully bad as the hero is good, has not a single redeeming feature.

Their conflict is so perfectly symmetrical that when the climax is reached and the hero begins to prevail, no one in the audience seems to think it at all odd that this ingenuous youth now rakes his opponent's face along the ropes and kicks him in the belly. Well, some might say, it's only a show of course, a morality play on the edifying theme of the invincibility of innocence, and no real harm is done.

What Makes Art Bad?

But continual exposure to such a plot and its variants may, in fact, have a bad effect, may inure us to yahooism. On Route I-90, about thirty miles east of Cleveland, one of the many overpasses had this message scratched on it: "Nuke Iran." That inscription, made in 1980 and remaining there into the summer of 1988, confirms what we have heard about the neglect of the infrastructure in the United States, but it also affords a glimpse into the nation's mind-set. After all, in recent years we have often felt the impulse to employ extreme measures. Lebanon, Grenada, Libya, Nicaragua, Panama, Iraq have all felt our wrath. Fortunately, our leaders have not gone all the way and nuked Iran or anyone else. But, more conscious than good sense allows of their own perfect probity, they have mined harbors and promiscuously bombed and shelled, and the results, which include the deaths of children, women, old men, and the residents of an insane asylum, have not won us many friends among foreigners, who are less convinced than we are of the immaculate innocence which entitles us to take such fierce actions against our opponents. And the great national pastime of television reveals the lowness of thought and the incivility that now characterize many programs of news commentary. "Crossfire," "McLaughlin and Company," and other such shows are based on a crude confrontational tit-for-tat in which advocacy degenerates to screaming and brazen vilification. The danger of these programs is less their superficiality in conveying the news than it is their insistently repeated lesson that the proper outlook on public affairs is sneering spitefulness. Those who feel that they are completely right also feel that they can do anything and say anything to insure that their right prevails. Frequent doses of bad art prepare our minds to receive such teaching.

In his masterpiece *City Lights*, working with comic material and appealing to a very large audience, Charlie Chaplin was able to express a frame of mind quite as complex and unusual as the one Shelley presented. Although the film was made in 1931, in the period of talking pictures, Chaplin almost entirely dismisses sound, only using the noise of deliberately garbled speech in one section but keeping the film silent elsewhere and very sparingly captioned. Mainly Chaplin depends on mime to convey the story. A brief segment illustrates his power to give compact expression to a complex state of consciousness. In this segment Charlie, the impoverished tramp, comes across a beautiful blind flower girl who sells her flowers

on a busy street corner in the downtown of a great city. The time is the late afternoon rush hour. Overcome with sympathy for the girl, Charlie digs into his pocket and pulls out the one coin he has left—a quarter perhaps—and looks at it yearningly before handing it to the flower girl. She gives him a flower for his lapel and takes out change from her purse. At just that moment a rich man, presumably a banker, steps up to his waiting limousine at curbside, gets in, and slams the door. Thinking that Charlie is the rich man and is leaving without taking his change, the girl gratefully calls out to him, "Thank you!" and puts the change back in her purse. This leaves the little tramp in an awkward predicament. His motive has been generous—he really does want to help the poor beautiful flower girl—and so he has impulsively parted with money which he needs for himself. Still, he didn't mean to be *that* generous; he wants his change. But asking for it now after being so sweetly thanked would meanly spoil a gracious and happy moment. Charlie lets it go with a shrug and a quizzical smile and softly walks away so that the flower girl will not hear him.

So what state of mind does this episode express? Generosity? Not entirely so, for the little tramp did want his change back and felt at least a twinge of self-pity. After all, Charlie doesn't know where his next meal will come from. Regret? Well, yes, for a moment, but only a very little, and that little Charlie quickly overcomes. Acquiescence? Not really. Charlie does more than accept this innocent spoliation; he romantically embraces it, and his heart gallantly goes out to the lovely girl. The episode reveals a very particular and powerful mental activity, but no one has yet given it a name. And that is its difference from the wrestling match. Finding names for the attitudes embodied by the wrestlers is not difficult, for these attitudes are very common. Nearly all of us at heart are convinced that we are innocent and good, that the people who get in our way are evil, that we have a right to be savage in defending ourselves and our principles. When we make a patriotic displacement of these feelings we say, "Nuke Iran! Bomb 'em! Gas 'em! Exterminate the brutes!" It is a wicked thought and perfectly familiar.

To sum up, then, professional wrestling matches are bad art, first, because of their banality; they present modes of consciousness that the audience already possesses. Second, they are bad because of their falsity; they portray mind-sets which distort the real world, as happens, for instance, when the wrestlers fake unmotivated changes of heart from cruelty to kindness. Third, they are bad because of their immorality; they deny the dignity of life when the "good guy," with the crowd's approval, degrades the "bad guy." By observing the wrestling matches we have gathered principles which seem to mark bad art in general, whether it is the featureless din of an ugly rock song that bumps along with stultifying repetition or the crudely designed shopping mall in which spaces line up like so many pigeons squatting on a sidewalk.

Examples of Good Art and Bad

Bad art takes other forms than professional wrestling of course, and some examples of badness come to mind. There is potentiality for harm in the art which depicts animals as possessing human or nearly human intelligence, a misrepresentation which fairly often occurs in popular fiction (especially children's literature), televised drama, and in magazine illustrations.[3] Lassie and Rin-Tin-Tin were the prototypes of a kind of badness in the fictional presentation of animals which is still perpetrated on television. This kind of art is wrong, first, because it sets us up for disappointment when we see that our own pets lack the sagacity of the wise dogs and cats and horses and dolphins that appear in many a story and movie. Second, and more serious, in spite of their charm, these artworks weaken the basis for advocating animal rights, really cut the ground out from under the people who are campaigning to end the mistreatment of animals. After all, the special ethical duty that we owe to the other higher animals derives from their inability to adjust to the environment which we humans have made. If their intelligence were as powerful as ours, they would be our equals and would have no call on us. The other animals are not humans in a different shape; they are authentically what they appear, creatures that must carry on the fight for happiness without our human strengths and therefore, we are beginning to feel, with our help. Good art about animals, art which presents ideas compatible with their real character, opens our minds to the mysteriously attracting otherness which combines with the sympathy between them and us to make all the closer bond. Jack London always keeps his readers aware of the other-than-human features of his animal protagonists. Buck, the hero of *The Call of the Wild*, delights us because we know that he is a dog, not a human, and when we exult with him in the fate which he wins for himself at the end, a fate which would be intolerable for ourselves, we have gone a long way in adjusting our minds to alien possibilities of embracing life. We feel the same way about the panther Bagheera and the lead wolf Akela in Kipling's Jungle Books. A more recent writer, Richard Adams, in his popular *Watership Down*, may seem to humanize his animals when he gives them pretty names, but his creations remain essentially wild animals, rabbits and not hominid bunnies, and he subtly reminds us of their difference from ourselves when, for example, they smell cigarettes and associate them with human beings but nevertheless fail to understand what use humans make of them. Thomas Hardy, who often wrote about animals in poems that reflect biologically accurate views that are also deeply felt, conveys the sense of their otherness from ourselves.

The most notorious form of bad art is pornography, and the advantage to us of examining this explosive subject is that it starkly exposes the problem of bad art and therefore allows us to discuss it more clearly. In treating it at all, the first thing I have to do is stand back and then take a running jump at it by making a confession and offering an excuse. The confession: I have both read and watched pornography, I have enjoyed it,

and I have not committed sex offenses. The excuse: I do not know how it is with women, but I am pretty certain that nearly all men have enjoyed pornography and that nearly all those who deny it are lying. I only make this confession and the excuse in order to put a little light on a very murky subject by pointing to the source of the most abundant and clearest evidence, our own experience, which we understand much better than we can ever understand the confusing evidence which respondents report on questionnaires or which psychiatrists and clinical psychologists deduce from their treatment of patients.

And what my own experience tells me is that pornography does not cause me to commit sex crimes. Moreover, my own experience is many times repeated in the lives of others so that we can say, at least for much the greater part of the population, pornography does not instigate criminality. A little consideration of the matter reinforces the conclusion suggested by experience. The sexual appetite is extremely powerful and, like hunger, arises quite naturally with no special occasion or stimulus needed to provoke it. It leads many to an interest in pornography, and some of those who sample pornography, less capable of defending themselves against the criminal urge, it also incites to sexual crimes. It is the appetite itself which is the driving force, leading both to the pornography and also the criminality. Both experience and reason come to the same conclusion: sexual appetite leads to pornography, not the other way about.

Still, the unlikeliness that pornography causes sex crimes does not prove that it is a harmless amusement. Generally people seem to agree that pornography is bad because it imparts a harmful life-envisagement for conducting the relations of two persons in a situation where sexual attraction exists, the right envisagement being provided in the art-fostered images of romantic love, which associates the loved object with tender feelings and, in particular, with the deep respect that we always grant another when we emphatically affirm that other's personality. Beyond this superiority, romantic love is better than the love relationship schematized in pornography because it satisfies human desires which pornographic love cannot possibly fulfill—the desire, for instance, to be related to an idealized, imaginatively perfect person. So much, I think, we would all grant.

What, then, is essentially wrong with pornography, our example for the moment of bad art in general? I think that the main harm it does is its suggestion that some people do not have the same natural rights as others. In watching or reading pornography we are likely to identify ourselves with the character who takes advantage of another by some form of dominance—physical abuse, manipulation, humiliation. The human relationship in pornography is usually unequal: one character is allowed to do things which the other must endure. The real harm of pornography is that it lowers our sensitivity to human rights, particularly to those rights like respect and privacy which are guaranteed more by common feeling and tradition

than by formally codified laws. The daytime soaps, porn for the fastidiously lecherous, illustrate the blunting of this sensitivity.

We have been examining art which is bad because it is banal, reinforcing trivial impulses of thought or feeling which we already possess, bad because it is false, or bad because it is immoral, limiting our own or others' chances of growth. But unfortunately the banal, the false, and the immoral are not always disagreeable, and they are seductively cultivated by much popular television fantasy. This bad fantasy projects highly luxurious, selfish life styles and then suggests that these ways of life are admirable. My complaint against them is that, in spite of all their opulence, these fantasies are only vulgar expressions of very crude motives: cupidity, sneaking venality, control. The men are louts, the women broads. To see how anti-art these hymns to power are, think what would have happened if the kitsch Victorian house in "Falcon Crest" had been replaced by a Frank Lloyd Wright house or the phony Greek revival mansion of "Dallas" with its chintzy, stuck-on facade, by Jefferson's Montecello. What would have become of those bores the Carringtons if even a minor character out of Shakespeare, Chekhov, Arthur Miller, or Ibsen had strayed into an episode of "Dynasty"? Could "Life Styles of the Rich and Famous" mount a segment on Whoopi Goldberg or Robin Williams and survive? A whiff of good art would blow these confections away.

We have gone far enough to find the basic distinctions of bad art and good. Just as bad art is platitudinous, mendacious, or immoral, so, by contrast, good art is seditious of habitual attitudes, or importantly true, or affirmative of life. In Chapter Six we shall more closely examine these characteristics, but now we can look for them in a very familiar art form.

A Good Art Form

Our examination of wrestling took a popular art form, one attended by millions, and showed what is the bad effect of it on our envisagement of life and our mental operations. Incidentally to this examination of bad art we noticed some art works of high quality and saw that they project states of consciousness which closely match the world as it really seems to exist and thus ready our minds to accommodate reality. But a detailed study of a very widespread art form will show more fully what good art does for us. That art form, surely one of the most common and oldest, is the cemetery. Although cemeteries closely connect with religion, nonetheless they are essentially art just as church buildings and stained glass windows are art, religious art.

Cemeteries are vastly different from each other in size and in their placement, but in most ways they are alike, with only superficial differences, at least in Western Europe and America. With such exceptions as

military cemeteries and old cemeteries in England and the northeastern United States, the monuments in a cemetery are highly various, some being life-size statues, some genuine mausoleums ornately decorated, some mere grave markers, others carrying verses about the passing of time or the universality of death. Moreover, the grounds imitate a country garden, even when a cemetery is located near a city's center. Trees, shrubs, and densely packed flower beds embellish the grassy area. But the profusion does not run wild. The variety is regulated so as to produce one whole effect of tranquillity. First, the monuments themselves form a pattern by being placed in nearly even rows at a regular distance from each other. Second, within family plots the tombstones are identical with each other for the separate graves, but then one larger stone will designate the whole family, and the consequent gathering of the sets of stones, each set organized around its central monument, produces clear but fluid patterns and heightens the effect of ordered abundance and serenity. Then, finally, cemeteries are laid out in a regular and almost strict fashion. They are crisscrossed by service roads and by smaller paths at standard intervals, and the whole burial ground itself, unless it is extremely large, is a nearly perfect square or rectangle. To an extent unusual even in art, which in general aims for both unity and variety, cemeteries take highly diverse individual segments and put an order upon them. The overall effect combines the strict logic of a classical French garden with the exuberant vitality of an English garden. As a result, in many cities the finest, most beautiful outdoor space is the cemetery.

So, then, even though cemeteries fulfill ritual purposes, they also meet the conditions of art. They are set aside in a way to concentrate the observer's attention exclusively on them as objects to be viewed carefully; they are made to interest the mind and seize and gratify attention by being constructed out of a complex interplay of elements which, however various they are and different from each other, nonetheless are brought into unity; and all this refinement in the object, the cemetery, grips the attention, prolongs and shapes it, fills it.

Linguistic Meaning and Artistic Import

With what? When we asked that same question about professional wrestling, the answer came readily: those matches inculcate the myth of the invincibility of innocence, the crazy but common notion that I am a good guy and that being a good guy—exuberantly healthy, eternally young, handsome, exulting in the plaudits of the adoring crowd, totally right—I can do anything I please to you bad guys—old, weak, scheming, despised, and ugly. Interpreting professional wrestling is easy because this trivial form of art is all surface and no depth. But cemeteries, though they undoubtedly affect our minds, do not readily translate into plain meaning; they are non-propositional.

Like language, art is symbolic, and any artwork, good or bad, is a set of symbols just as a sentence is such a set.[4] But these two symbolisms, art and what I am now going to call "ordinary language," normally serve different functions. Before naming these functions I had better clear up my use of the term "ordinary language," which for me refers to all language whatever *except* artistic language, the language of poems, plays, novels, and the personal essay.

Now we can go back to identifying the different functions which the two symbolisms discharge. One function is communication, the conveyance of information from one person to others, and this is almost exclusively the province of ordinary language. The only other important communicative form I can think of is conventional gestures, and these are very limited in the amount and variety of information they give. Road signs and mathematics formulas are not really exceptions, for both are kinds of shorthand writing and stand for words. No doubt, communication is the highest function of language, for it immediately undergirds thought, which the Spanish writer Unamuno aptly said is the thing that language does in us.[5]

Basic to communication and still employing ordinary language is formulation. This function is a diverse set of activities, but the one I am thinking of now is merely using language, most often just single words or brief phrases, to fix certain items in the mind. A shopping list is an example.

soap, flour, eggs, light bulbs, Tops

Indefinite as it is, this list would not give much guidance to someone shopping for me. It does not specify face soap or laundry soap, does not indicate what brand of flour I want or how many eggs or what watt light bulbs. On the other hand, it does give a brand name, Tops, because I have coupons for their two percent milk. This abbreviated note, nearly useless to anyone else, is as much as I need to call to mind just what to buy once I am in the store. The simple notes we use to prompt ourselves when we give a talk are also formulations; the few terms on a little sheet of paper trigger our recall of complex assertions and full demonstrations that we have previously worked out.

What the symbols do when either communication or formulation is involved is bring to mind things which are not present to the senses. Those things may be real or not real, visible or invisible. Thus, I look at my shopping list, see "soap," and then think soap though at the moment I am in the canned goods section. The other higher animals, not using symbols, do not do that. Nothing will make them think soap but the very bar of soap itself. That is the conclusion to be drawn from some of Köhler's famous experiments with chimpanzees.[6] In certain experiments Köhler confined a chimpanzee in a cage and then, in front of the animal but beyond its reach, outside the cage placed a banana and, nearer, a stick. Without difficulty or

hesitation, the chimpanzee pulled the banana into the cage with the stick. What this part of the experiment shows is that the chimpanzee was able to solve a problem, that it had intelligence in the sense in which we ordinarily use that term. Another part of the experiment was just like the first, but with this crucial difference: instead of putting the banana and the stick in front of the chimpanzee as in the earlier case, Köhler placed the banana on one side of the cage and the stick on the other. This time the chimpanzee was unable to secure the banana. The inescapable conclusion is that while looking at all the relevant objects the chimpanzee can think "a banana and a stick," but it cannot look first at one then at the other and, with the first object invisible, think, "a banana and a stick." For the chimpanzee the rule is out of sight, out of mind. By watching our pets we can confirm Köhler's observation. Undoubtedly primates, cats, dogs, and several other species are intelligent, capable of understanding much of the world for what it is and dealing with it so as to attain their own desires, but their intelligence is not elaborated, as ours is, into reason. Intelligence is what we possess in common with the other higher animals. But reason or imagination is ours alone, the consequence of our use of symbols.[7]

Ordinary language can bring to mind things in the world that are not at the moment physically present. Both communication and formulation do that. But what can bring into consciousness a particular pattern or flow that the mind itself assumes out of the myriad states or movements that are possible to it? The answer is art along with the other experiences of attending. This conversation suggests the difference in function of the two symbol systems.

You: What did you do yesterday?
I: I went to ride on my bicycle.
You: Did anything interesting happen?
I: Oh, yes! When I was riding along a country road, all of a sudden the sky got black, and the wind blew, and a terrific storm came on with thunder and lightning.
You: Weren't you frightened?
I: I was scared to death. I felt as if I were being punished for something wrong I had done but hadn't been told what sin I had committed.

Up to the last speech the dialogue is all pretty much straightforward communication, you calling for information about the external world and I giving it. That is the way with ordinary language or discourse as we have also been calling it. But clearly something quite different happens in my last speech. That speech is not at all about the real world, for it begins with a counterfactual statement, "I was scared to death," and it proceeds to other counterfactuals which the expression "as if" signals as not being literally true. The last speech is not discourse; it is presentation. Rather than conveying information about outer reality, it expresses, or at least begins to

express, the inward world of mental activity. If I had artistic talent I might be able to develop this presentational kernel into a complete art object, perhaps into a play like *Macbeth* with its storm that is the background for Macbeth's meeting with the witches at the beginning of the play and which continues on through the scene in which Macbeth murders Duncan. Or, if my talent were for music, I might take this seed and mature it, like Mahler in the fourth movement of his First Symphony, into an intertwining of the two opposite motives of serene conserving and of hectic destructiveness.

But let's take the dialogue just as it is printed above and try to see what are the respective benefits to be gained from the discursive and the presentational parts. The discursive earlier part is plainly good because it conveys true information about the world. And what of the presentational segment? What use can it possibly have? One use is that we can literalize the "as if" statements and then ask ourselves such questions as: "Have I in fact done something wrong?" "Am I being punished?" "Is it a sin just to go on living as the person I am?" If we take those questions seriously and really try to answer them, we shall eventually end up with a theology, either our own or one that we have adopted from some other source. Or we can literalize the presentation somewhat differently and ask, "Was the storm a person, or was it a power?" "Is a power less than a person or more?" "Is there only one power in the world, or is there more than one?" If we begin with those questions and go on far enough we shall arrive at a physics and a metaphysics, again our own or someone else's. My point is that presentations, treated seriously, have a way of transforming themselves into discourse. The transformation of presentations into such major discursive sciences as theology or physics takes place over immense reaches of time, millennia indeed, and it is conducted by geniuses. Ordinary individuals have little direct part in carrying on the process, but they receive its benefits nonetheless.

On the other hand, presentation also confers a more distinctly personal kind of good. If we look once again at my last speech we see that the "as if" statements express a frame of mind which is poised to notice the phenomenon of things as they turn into their opposites. We habitually think of nature as benign, but in this case it was the reverse. Perhaps the most insistent presentation in art is just this one of things' becoming their opposites. Literature and drama incorporate this presentation in their ubiquitous theme of appearance *versus* reality; sculpture gives it through the chiaroscuro effect of playing light and shade on a surface; architecture achieves it through symmetries and asymmetries that reflect, conceal, and also distort a form; music embodies it in the contrast of melodies, rhythms, dynamics, and tonalities and then the interrelating them either in a simple A-B-A pattern or in complicated symphonies, sonatas, and fugues.

This mode of consciousness, the one that is ready to see in a thing its opposite or some considerable modification of it, is exactly the one that

humans, as rational animals, most need. We inveterate symbolizers need to understand that symbols can mislead us. Although symbols vastly increase the amount of reality which we can hold in our minds, they also trick us into confusion and error. We are everlastingly misconstruing some aspect of our environment. We overestimate the faithfulness of a friend and are devastated to see the friendship dissolve through a petty conflict. We are dragged into a lawsuit because a neighbor or a customer gives to a word we used a meaning different from the one we intended. We believe we have the stamina to go out for a ten mile run, and we spend the following week in misery. We even think we can follow the instructions for building a bookcase and end up with a heap of battered junk littering the floor. We make mistakes constantly because our minds deal with our images (symbols) of things and not with the things themselves. Art comes to our rescue by being just as persistent in reminding us that things are not always what they seem as we are stubborn in our recurring delusion that they really are what they seem. So art in every form, from a popular folk song like "Frankie and Johnny" to a grand opera like *La Traviata*, keeps reminding us that what appears is not necessarily the same thing that really is. This same mind-set is conveyed to us in one way by the shimmering insubstantiality of Monet's water lilies and in another by the doubling of the Odette/Odile figure in *Swan Lake* or the contrasting of the characters of Hilda and Miriam in Hawthorne's *The Marble Fawn*. Another variant of the same presentation is offered in Michelangelo's *Slave*, where the struggling human figure never manages to free itself from the confining stone, and still another is in the close similarity and yet decisive difference of the male and female figures of Ingres' drawing *The Golden Age* or of Rodin's more aggressively erotic sculpture *The Kiss*. And I can even say in defense of professional wrestling that watching it was the best preparation I could possibly have had in order to deal with the politician who returned from a trip to Central America and intoned, "What we are witnessing in El Salvador is the emergence of democracy." Ironically, symbols, which are our only hope of knowing the world in its complexity, often do not at all match the world. And our clearest, most consistent, and most emphatic teacher on this important point is art.

We have already seen that the content of the two different symbolisms is different. Discourse deals with the "outside" world of objects, and presentation deals with the "inside" world of psychic activity. We need to add now the main formal differences between the two. Discourse uses conventional signs with fixed referents in the real world, and it is segmented; presentation uses signs which acquire import through their connection with other signs in the artwork, and it is unitary. The symbols which discourse uses are, first, words and, second, a particular arrangement of those words. Both the words and the arrangements are conventional, are governed by rules which all members of the discourse community accept with very little allowance for variation. For instance, if I am going to convey meaning to you in ordinary language, I have got to use words in their regular sense; I cannot shuffle my vocabulary so that I use the words

"stones are heavy" to mean what you state by saying "we enjoyed ourselves." It is not discourse if I do that. Similarly, just so many arrangements of the words are allowable. This present sentence will have meaning for readers, for example, only if it follows certain patterns and not others. The segmentation of discourse results from conventions concerning words and word orders, for since only a limited number of meanings for a word and only a few orders out of the many possible are permitted, any intelligible sentence breaks apart—segments—into sections that are identical to sections in other sentences. Thus, we learn in school that all sentences have a subject part and a predicate part and that these parts subdivide into further standard sections that grammar books describe.

By contrast with discourse, which gives us material bit by bit, presentation offers us one whole form made out of many elements: all the different notes, melodies, rhythms, and tonalities of a symphony or all the many kinds of pose, step, costume, and lighting effects of a dance. Rarely do any of these elements stand in a one-to-one relation to a referent in the way that words and sentences do. For instance, in dance the pose called *attitude* does not convey any fixed meaning like "horse" or "I'll meet you in the morning." Instead the pose gradually builds up an import in our minds as it intersects and interacts with the other poses in a particular dance, with the steps, with the flow of movement, with the forms made by the placement of dancers in relation to each other, and by the story in the case of a dramatic ballet.

As a consequence of these differences between the two symbolisms—ordinary language and art, discourse and presentation—we cannot directly translate the one into the other. Therefore, I cannot complete a sentence that begins, "The meaning of cemeteries is...." Worthwhile art objects do not have "meanings," objective statements about the real world; rather they have "imports," presentations of the forms and states and flows of the activity of the mind itself, what elsewhere in this book I have called "sentiences," "psychic states," and by other names. Therefore, instead of saying what a cemetery "means," I have to point to its import by identifying its most salient characteristics. Here they are. (1) Most basically a cemetery is a burial ground. Anything else it is, is an addition to that. (2) A cemetery is a garden, more exactly landscape architecture, which combines a rather strict order (e. g., headstones arranged in fairly straight lines) with a free flow (e. g., fairly wide variety in size and design of individual monuments). Thus the headstones group themselves into separate and distinct plots, but the adjacent plots are open to each other. (3) The monuments stress both the deceased person's individual identity and connection to other people. They give names, dates (sometimes the date of death is not filled in), and often genealogical relations ("daughter," "father"). (4) Cemeteries are carefully tended. Even small, out-of-the-way burial grounds seem to be well looked after, and a really abandoned one is hardly imaginable. In engineering new roads and other improvements, communities go to extreme lengths to preserve cemeteries and not to dis-

turb them. Vandalism is rare and very shocking whenever it occurs. Old gravestones that have fallen over or disintegrated are restored as much as possible.

So, then, cemeteries present to us two contrary elements that are bound together in one state of consciousness. The one element is the obvious theme of death given by the cemetery as place of interment. But this theme is much modified in the presentation by the other theme of the cemetery as landscape architecture, a carefully tended public garden, full of grass and trees and proportioned, as all noble architecture is, to create what Suzanne Langer calls the ethnic domain, the space that seems to live.[8] Moreover, this second theme is strengthened by the headstones, which, with their names, dates, and stated family relations, carry the dead and buried right out into the ongoing stream of life of generations who preceded and followed them and are yet to come.

This appreciation of cemeteries as art works is not an interpretation that declares their "meaning." Instead it is an apprehension of import, a seizing of the mental processes which they incarnate. The apprehension is not yet reason, but it takes a step along the path to reason. It performs the service of presentational formulation; it is a symbol which allows us to hold onto a highly complex mental state, and this particular formulation presents a set of mental activities that are quite different from those projected in other, grimmer symbols—skulls and crossbones, skeletons, charnel houses. Under the tutelage of cemeteries we may ultimately achieve a state of mind which will allow us to conceive of death in a different way from the dark superstitions and fearful avoidances that afflict us now.

FOOTNOTES

[1]Quentin Bell, in the title essay of his book *Bad Art* (Chicago: University of Chicago Press, 1989), 9-26, treats this subject in a way that differs from mine but which also complements it. Having chiefly pictorial art in mind, Bell thinks that an artwork is bad when the creating artist falls victim to false sentiment, more exactly, when the artist surrenders his or her own vision in order to adopt the socially accepted view. Both Bell's account of bad art and my own see the stereotype as the central fault.

[2]For a thorough analysis of this subject see Michael R. Ball, *Professional Wrestling as Ritual Drama in American Pop Culture* (Dyfed, Wales: Edwin Mellen Press, 1990).

[3]But at least one notable exception must be made to this general stricture against attributing human intelligence to other animals. It is the wonderful scene in the *Iliad*, Book XVII, in which Achilles' horses weep for the fallen Patroclus and are consoled by Zeus himself. Why is it that the conceit of animals' possessing human mental qualities usually produces bad art but in this one case is acceptable?

[4]Both language and art are symbolic sets, but only language can be called a system, an arrangement of parts determined by the function of the whole. Art seems to be a much more aleatory affair in which the function, rarely predetermined, is more often an accident, at least incipiently, than a planned result of consciously selected symbols.

[5]Miguel de Unamuno, *The Tragic Sense of Life,* trans. J. E. Crawford Flitch (1921; New York: Dover, 1954), 143: "...the language with which we think, or, rather, the language which thinks in us."

[6]Wolfgang Köhler, *The Mentality of Apes*, trans. Ella Winter (2nd ed., 1927; London: Routledge & Kegan Paul, 1956), 37-38.

[7]Another writer's succinct and persuasive expression of this same view is Jacob Bronowski, "The Reach of Imagination," *Proceedings of the American Academy of Arts and Letters and National Institute*, Second Series, Number Seventeen, 1967; rpt. in *The Folio Anthology of Essays*, ed. Frank Delaney (London: The Folio Society, 1990), 202-209. Bronowski makes much the same use of the experiment with dogs by the American psychologist Walter Hunter which I make of Köhler's work with apes. Bronowski's word "imagination" comprehends my ideas of "symbolism" and of "reason."

[8]Susanne K Langer, *Feeling and Form: A Theory of Art* (1953; London: Routledge & Kegan Paul, 1967), 95-101.

CHAPTER FIVE

The Place of Art

in the Hierarchy of Learning

Gagné's Hierarchy

The argument of this book is that the experience of art contributes importantly to the development of reason, and the argument of this chapter is that the notion of art experience can add substantially to the theory of learning that is most generally held by educators. My argument concerning the relation of art experience to learning hinges on the symbol. The connection among art, language, and reason is the symbol: each one of these activities is carried on through symbols, the function of which is to bring into consciousness realities that do not readily offer themselves for direct physical inspection. The symbols of art objectify for us the countless distinct operations of consciousness, the forms that the mind takes as it goes about its business of questioning, recalling, analyzing, affirming, negating, willing, and all the rest. Just as art symbols project the inner world of mental life, so the symbols of language represent the facts of the outer world. Reason, the complete act of mentation, accommodates the internal operation to the external reality.

Now I want to show that my view of the value of art experience, along with such other attending experiences as ritual and nature study, is not at odds with standard psychology of learning. Over the many years that educators have been thinking about instruction, a widespread point of view on learning has grown up, a view which merges together the results of teachers' reflections on their experience, subject matter specialists' inquiries into the fundamental structures of their different disciplines, and the observations and experiments of psychologists. The consensus that has arisen out of these disparate sources is a bit too ragged to be called an exact science, but its idea of the way people learn is clear enough to guide teachers and curriculum planners in their work. It is a perennialist educational psychology, not especially behaviorist or cognitivist or humanist, but absorbing conceptions from all these more specialized explanations in order to give a general account of learning in its many forms. Perhaps the best known expression of this educational psychology is Robert Gagné's *The Conditions of Learning*.[1]

Over the four editions which appeared between 1965 and 1985, Gagné's work underwent many changes which kept it current with the evolving tenets in the field of educational psychology. From the beginning, Gagné organized the forms of learning in an hierarchy of eight layers, each successive layer adding a small increment to the kind of mental activity in the layer just below it and the whole hierarchy thus originating in the most simple mental acts and mounting up to the most complex. At the bottom of the hierarchy is signal learning, and above it are the stages of stimulus-response associations, chaining, and verbal associations; then progressively higher are discriminating, concept learning, rule learning, and finally, at the apex of mental functions, problem solving.

Using the study of mathematics as his most frequent example, Gagné shows that the organization of information in each of the disciplines increases in complexity along with the elaboration in the stages of the hierarchy. He asserts that acquiring a discipline (mathematics, chemistry, grammar, etc.) involves the whole hierarchy of abilities as the learner advances from the position of neophyte grasping the most simple parts of a subject to the status of master commanding the complex and difficult parts and exploiting the discipline in order to solve problems.

We can illustrate the layers of the hierarchy and the necessity of learners' passing through those layers one after another if we take an elementary arithmetic problem, the problem, say, of finding out how much money each person in a group of four must contribute if that group equally shares the cost of a box of candy priced at exactly six dollars. There is a set of rules for solving the problem; it is the form of long division. Supporting the set of rules for division are certain concepts about number, the notions, for instance, that numbers can be more or less than other numbers and that therefore smaller numbers can be added together to make large numbers or can "borrow" units from larger numbers. Behind these notions are crude discriminations of more and less and of larger and smaller (the discriminations that Piagetian psychologists call "concrete operations"), and these discriminations, in turn, arise from such verbal associations as "wait a minute," "I'll give you just ten seconds," "I love you oodles and oodles." It is necessary to avoid confusion at this point by emphasizing that the category "verbal association" in Gagné's learning hierarchy is not the same thing as language as it is normally understood.[2] True enough, such an expression as "wait a minute" is comprised of words, but it only acts to stimulate one particular response in a hearer, not to convey information. Thus, the expressions given above operate on a human learner in much the same way that the words "Gee!" and "Haw!" affect a horse or "Good girl!" a dog; they reinforce particular behaviors. It just happens that verbal associations—words—work better than all the other sensory reinforcers of behavior because words are easier to vary than lights, colors, gestures, or inarticulate sounds and thus are more adapted to rewarding and instilling a variety of behaviors.

By the fourth edition of his book Gagné has retained the eight-stage learning hierarchy, but he has added an important feature which he had scarcely touched on in the first and second editions. This new element Gagné calls "cognitive skills," the metacognitive abilities through which learners take charge of their own mental activity, get it started, guide it along certain tracks, monitor its development, choose to suspend or redirect it. (55-56) Thus, focusing attention, screening out distractions, calling up information and controlling its flow, and selecting a specific response to a particular situation are all consequences of these cognitive strategies. Perhaps the operation of computers is a fair analog of the connection between the learning hierarchy and cognitive strategies, with the learning hierarchy equivalent to the files of encoded information and potential action and the cognitive strategies like the computer application programs which put the files into effect.

Gagné says that psychologists do not fully understand the cognitive strategies (58, 143). But he seems confident in asserting that the strategies are learned (79), that they are not learned equally well by all persons (57), that they are independent of any particular content and thus highly portable from one field of learning to another (56), and that at least sometimes they are embedded in imagery rather than words or formal intellectual systems (159, 161). Gagné has nothing to say about the nature or the appreciation of art, but nonetheless his psychology seems eminently well suited for having grafted onto it the ideas about presentational symbols which are a large part of the subject of this book. If we assimilate Gagné's "hierarchy of learning" and his "intellectual outcomes" to *discourse* and his "cognitive strategies" to *presentation*, we have a working accommodation between his ideas about the operation of the mind and the ideas about art experience which we have previously described.

I do not attribute solely to art or even to the whole range of attending activities—art, religion, nature study, observation of sport—the entire work of creating the cognitive strategies. But I do suggest that aesthetic attending offers those presentations of mental life through which humans are most likely to surmount the lowest rungs of the learning hierarchy where the other higher animals are fixed. Those presentations, I claim, empower our human minds to go on to the acts of discrimination, conceptualizing, rule learning, and problem solving that distinguish humans and are their own adaptive mechanisms for survival as a species and for happiness as individuals.

The other higher animals clearly are intelligent, and up to a point their intelligence is much like ours. Clearly such animals as cats, dogs, and apes know what fire is, for instance, and the proof is their keeping away from it. But, as we saw in Chapter IV when we discussed Köhler's experiments, those animals represent different objects to themselves only when the objects are actually present in their immediate vicinity, not when they are absent. To a limited degree they can *deal* with sticks and bananas, but

they cannot *think* about them. They have keen intelligence, but they lack reason.

The difference of intelligence that owes to humans' use of symbols was sadly illustrated for me when I had to have one of my cats euthanized. His life was drawing to an end, and I wanted to spare him any more of the discomfort that he was undergoing. I do not exaggerate to say that I grieved for him. And why not? For thirteen years he and I gave each other much happiness, and then suddenly our life together was all over. But my remaining two cats, who were fond of him also, showed no sign of sorrow whatever. The reason is obvious as soon as the fact is stated. They do not know that their friend is dead. More than that, with little or no power of symbolizing the absent one, they have lost all trace of him. Could he return, they would of course know him and greet him just as they greet me when I come home from work. But they can no more think of him who is forever absent than they can work math problems or read poems. What is not physically present—or giving signs that it just was or soon will be present—is not in their consciousness at all.

So, then, although all the higher animals have the capacity to recognize a thing when it appears before them, only humans have the still more advanced capacity for *symbolization*, the ability to bring a thing to mind when it is not physically present. And it is just this ability that allows us to form concepts. Suppose, for example, we develop a concept of power; what we do is take numerous instances of different kinds of power—a powerful horse, a powerful engine, a powerful voice, a powerful argument, a powerful explosive, a powerful speech—and then we see what element they all have in common. Such seeing requires that we fix in our minds for contemplation things which are not actually before us. Similarly, when we go from learning a rule to solving a problem, the intermediate step of representing to ourselves all the possibly relevant rules is the work of symbolization, the capacity to take the physically absent and make it mentally present.

The Functions and Forms of Symbols

As to their function, symbols act in two different ways, both of which are necessary for thought to occur at a high level. One of the functions is to work inwardly and, by providing innumerable versions of the possibilities of being, to prepare the mind to identify the myriad different aspects of reality; this function can be called *connotation*. The other function of symbols is to work outwardly by linking up some of the forms which the mind has already generated with the observed phenomena of reality; this function is *denotation*. A complete and proper act of reason takes connotation, the mind's envisagements of its own operations and of life, and it links that up with denotation, the mind's estimate of what ac-

tually is there in the world. Take the case of my saying to myself as I become progressively better acquainted with a student: (1) "This student dislikes me." (2) "No, this student is merely indifferent." (3) "No, this student is diffident towards older people." What happens is that at each stage I run through my connotative symbols, my catalogue of envisagements of the world and of ways of understanding it, and I implicitly say to myself, "This connotation of mine really does denote that thing in the world." In the case just given, my first and second connotations having been disproved by a closer inspection of reality, I provisionally accept the third.

Now as to the forms of the symbols which fulfill the functions of connotation and denotation. The symbols which do the work of denotation are discursive; they are words that give the same idea, or nearly the same, to everyone. On the other hand, the symbols which serve the purposes of connotation are of two kinds. Some are discourse, illustrated above in my analysis of the student's attitude to me by the words *dislike*, *indifferent*, and *diffident*. But other symbols which are used for connotation are not instances of direct naming, discourse, but rather presentations which convey something analogously, by showing what it is like rather than giving it its own particular name. The preceding paragraph contains several presentational symbols. Some are the expressions "symbols act," "work inwardly," "work outwardly," and "linking up," all of which embody the idea of a certain process rather than merely name it. To be sure, these expressions are only faded metaphors, but nevertheless they stimulate very particular connotations which ordinary discourse, with its generality, could not arouse. In their remarkable book, *Metaphors We Live By*, George Lakoff and Mark Johnson show that our concepts of such basic things as love, argument, and time are rooted in metaphors which give substance to our thought even though we do not recognize the metaphors themselves until they are pointed out to us.[3]

Along with presentations in words go non-verbal ones that derive from aesthetic and other attending experiences of sound and sight. For instance, we saw in Chapter One that music conveys the virtual experience of time, a phenomenon which in our minds is very closely associated with the notion of cause. Listen now to the opening of either Beethoven's Symphony Number Five or Mozart's Symphony Number Forty-One (*The Jupiter*) and see how intricately each one enacts entirely different patterns of coming-to-an-end and related patterns of connecting. In the Beethoven the first coming-to-an-end is accomplished in just one phrase of four notes and is effected by changes in pitch, in tempo, and in stress, all on the last note. The little four note phrase is immediately repeated but with a difference of pitch that both distinguishes the repetition from the original phrase but also links the two. Then come a pair of three more repetitions but with still more obvious variations in tempo and pitch, and then the whole phrase gets so elaborated that only a technical and complex analysis could accurately describe these few bars of music. Now, if we turn to the beginning of Mozart's symphony we find that it is like Beethoven's in that it presents

patterns of coming-to-an-end and of connecting but unlike Beethoven's in respect to the exact patterns which it enacts. Between the two of them, Beethoven and Mozart give the stripped-down patterns of many different mental acts which, expanded by concrete denotations, can grow into the basic forms of logical thought. Consider this syllogism for instance.

> The good is that which all desire.
> That which all desire is being.
> The good is being.

Constructing that syllogism and then testing it for validity rest ultimately on discriminations, concepts, and rules that have to do with the phenomena of coming-to-an-end and of connecting end points. Specifically, when we manipulate syllogisms we have to know what are two-term statements, a series of three such statements, end terms, and middle terms. And these concepts and also the rules for testing formal necessity which the concepts support are intelligible only if we have a firm presentation in mind of coming-to-an-end and of connecting. Thus end terms are defined as the terms which appear in the end statement ("good" and "being") whereas the middle term is the one which does not get beyond the middle statement ("that which all desire"). As a matter of fact, speaking and writing are rarely done with the rules of logic consciously in mind, for reason and persuasion rest not only on the crisply stated concepts and rules of discourse but also, underlying these, on pre-verbal and even pre-rational insights expressed in the presentational symbols of music and the other powerful attending experiences.

As we have seen, presentational symbols which can stand at the base of substantial thought are stored in the different attending activities: sport, nature, ritual, some aspects of social relations, but above all in art. The presentational vat is going to boil up a lot of material, from crazy to inspired and from obscene to exalted. Discourse sorts through the presentations, suppressing some, repressing others into dream and fantasy, combining some, modifying others, and giving them names so as to bring them into full consciousness and shape them into a provisional sense of reality, a sense that keeps changing as a result of the continuous interplay in the maturing mind between increasingly precise discourse and a constantly expanding supply of presentations. Presentations function differently from discursive symbolism—ordinary language—because they do not refer, as discourse does, to the universe beyond the skin[4] but rather express various possibilities of mental activity, the whole gamut of proto-thought, proto-feeling, even proto-perception which lies in wait to match itself up, when opportunity arises, with some real thing in the world. Thought, feeling, and perception do not directly arise from external events in the straightforward way that a physical object causes the image on photographic film. Rather presentations arise spontaneously or else at the instigation of some activity of attending and then in a later discursive phase are sorted out and matched with external phenomena so as to make a cognitive match (some

kind of match, for we are constantly making mistakes and revising our conceptions) between the outside world and the psychic activity that goes on independently of it and that only from time to time accurately reflects it. The connotative machinery incessantly whirs on, continually spinning out presentational figures of dragons, griffins, unicorns, chimeras, and, occasionally of an actual worm, which denotation places in its discursive index of reality.

Therefore, when a human being thinks, which is something that no other animal appears to do, the thinking involves two different but complementary activities. One of these, wholly internal to the mind itself, is connotative, and it is carried on by presentational symbols generated within. The other activity is the denotative function of taking the inwardly produced symbol and matching it up with something out in the world or else realizing that there is nothing in the world with which it corresponds. ("That is a worm" or "There are no griffins really.") The completed thought brings together connotation and denotation, presentation and discourse, the envisagement of life and the observation of it. But the thing that has to come first is the connotation, the readying of the mind, by means of presentational symbols, to take in and identify phenomena of the real world. My young friend Katie, whose mental development I recounted in Chapter Three, illustrates this relation of the two kinds of symbolism. *First* Katie saw in her video cartoons episodes in which the animals crashed at top speed into rocks and trees, had their limbs swathed in immense bandages, hobbled here and there; *then*, when she saw a young man walking with a crutch and with a cast on his foot, she said, "That boy has hurt himself." *First* her mother and father read to her from her books the poems and stories about kindness and cruelty; *then*, confronted with the young termagant who bragged of being bigger, she said, "She doesn't love me." Actually Katie's learning from art the forms of consciousness goes still farther back to the time when she giggled with delight as I speeded up the rhythm of the "Pat-a-cake" rhyme and the time when she and I waltzed. In that pre-history of her intellect she was acquiring the most primitive symbols that, entering into everything that she thinks, feels, wills, and imagines, will ultimately present to her the substantiality of the world and the reality and gravity of her life and others' lives.

Presentations Transformed into Discourse

The presentational symbols supplied by art operate more subtly in the adult mind, pulling together more strands of connotation and denotation and producing thought or emotion or intention of much greater complexity and weight than Katie thus far has attained. An illustration of the intricate activity of presentations in mature thought occurs in an editorial that Andrew Kopkind wrote for *The Nation* and the correspondence that he and I exchanged concerning it.

Mr. Kopkind's short, unsigned editorial, "Medium Gains," which came out in *The Nation* on 3 October 1987, dealt with the possibility of rapprochement between the United States and the Soviet Union.[5] The editorial began by observing that the modest but real advance which Mr. Reagan and Mr. Gorbachev had made in their then recent summit meeting at Geneva would probably lead to the signing of a small-scale agreement on nuclear arms and that this accommodation, in turn, might eventuate in still more substantial accords. This is the way that Mr. Kopkind expressed the thought in the second paragraph of the editorial:

> But the treaty and the summit at which it would be signed are bound to mean more than the statistics of throw weights and firepower, which negotiators on both sides have been discussing for years. There is a momentum in the détente process that, unchecked, is bound to lead to more agreements at more points of conflict between the Soviet Union and the United States. Soviet leader Mikhail Gorbachev seems pleased to relent on internal policies such as the restrictions on Jewish emigration, which several U. S. Presidents have tried in vain to change by long-distance hectoring and threats. Even stranger, perhaps, is Secretary of State George Schultz's apparent interest in discussing some of America's own human rights issues, such as homelessness and Native American rights, in the general free-for-all. As more than one cold war correspondent has observed in the last few weeks, serious peace may be about to break out in the East-West theater of operations.

That paragraph had particular resonances for me. The second sentence sent me to the speech which Brutus makes just before the great battle in Shakespeare's *Julius Caesar*:

> There is a tide in the affairs of men,
> Which, taken at the flood, leads on to fortune;
> Omitted, all the voyage of their life
> Is bound in shallows and in miseries.
> On such a full sea are we now afloat;
> And we must take the current when it serves,
> Or lose our ventures.
> (IV, iii, 216-222)

Then in the last sentence the words "serious peace may be about to break out..." reminded me of John Knowles's novel *Peace Breaks Out*, and when I looked into my copy I found that in the prefatory matter Knowles quotes the phrase "peace breaks out" from Berthold Brecht's play *Mother Courage*.

So, then, Kopkind's editorial skillfully alluded to *Julius Caesar* and to either *Peace Breaks Out* or *Mother Courage* or both and showed the relevance of these works to contemporary politics. But was it that simple

and clean-cut? Other connections between Kopkind and the literary works might have existed. In my letter of inquiry to *The Nation* I mentioned three possibilities.

I can imagine only three ways that each of those parallels might have arisen in the author's mind: 1) as a deliberate, fully conscious literary allusion; 2) as an unconscious memory of the earlier text, only conscious at some time after the author first conceived it; 3) as an accidental, uncaused resemblance. I would be very grateful if the author wrote me a note...identifying which one of the possible explanations really applies to each of the two parallels.

Mr. Kopkind's answer, in a letter dated 27 October 1987, went right to the point.

In the examples you question: 1) the rhythmic, syntactical allusion to the line in *Julius Caesar* was semiconscious rather than deliberate. Looking back now, I think it occurred to me after I wrote the first phrase, "there is a momentum in the détente process," which recalled the Shakespearean antecedent. I see now that I could have, but did not, make it "there is a momentum *to* the détente process," which would have been acceptable, but would have injured the allusion. I may have been fleetingly aware of this at the time.

And 2) the allusion to Knowles/Brecht came from a deeper spot in my unconscious. I *was* vaguely aware of a formulation which substituted "peace" for "war" in a stock phrase, and if Brecht were listed as a possible source on a multiple-choice quiz I probably would have gotten it right. But the allusion here was not at all specific.

It appears that of the two literary allusions in the editorial, one (to Knowles/Brecht) was unconscious and the other (to Shakespeare) was semiconscious. The Knowles/Brecht allusion seems to be a fairly straightforward case of information retrieval; the phrase "peace breaks out" was stored in Kopkind's mind, even though at the moment he used it he was no more aware of its origin than most of us know where we first encountered the words we use. The allusion to Shakespeare is far more interesting, I think, and will cast more light on our subject of the place of art in the learning hierarchy. It is very different from the other allusion. For one thing, what Kopkind alludes to in Shakespeare is not a word or a meaning, as with the Knowles/Brecht allusion, but rather an ordering of words and, above all, a rhythm. He is unmistakable when he comments on this point, calling his reference to *Julius Caesar* a "rhythmic, syntactical allusion." We see how closely Kopkind's sentence parallels Shakespeare's when we put them together.

Shakespeare:
There is a tide in the affairs of men
Which, taken at the flood, leads on to fortune....

Kopkind:
There is a momentum in the détente process that, unchecked, is
bound to lead to more agreements....

Grammatically the sentences are identical: a dummy subject or expletive
("there"), followed by a copula ("is"), followed by the real subject that is
a noun plus prepositional phrase, and, last, a non-restrictive adjective
clause which is interrupted between its subject and predicate. This syntax
produces a distinctive rhythm: a steady rise of pitch, a pause, a word, a
long pause, an interruption, another long pause, resumption of the rising
pitch, a concluding monosyllabic falling pitch. It is a progression upwards
and outwards a little troubled in the middle, a marked rhythmic character.
An accidental rhythmic tag opened up the whole pattern to Kopkind. He
wrote the first phrase, "there is a momentum in the détente process,"
which happens also to be the first phrase of Shakespeare's rhythm, and
then that rhythm cued for Kopkind the rest of the words which he needed
to fill out the pattern. So rhythm, the presentational isomorph of one pos-
sibility of thought, was filled up with words, the symbols of discourse, and
thus was denoted into a cognition of the real world.

The subject Shakespeare's lines are about, their reference, is the
likelihood that when our lives begin to get better, they tend to improve
steadily, by their own momentum and in spite of obstacles. What Kop-
kind's sentence is about is his conviction that diplomatic negotiation may
acquire an energy and direction which will carry it to successful conclu-
sions exceeding the expectations of those who begin the negotiation. The
two propositions do not, at that level of denotation, have much in common,
for their subjects are very different—the happiness of a human's life, the
desirable outcomes of treaty making. But the rhythmic similarity of the two
statements shows what they have in common; it is their identical connota-
tive value. This particular rhythm is what Langer sometimes calls the
"morphology of feeling" and what I have been variously calling a
"sentience" or a "conformation of consciousness" or an "isomorph."
Strictly speaking, it is only half a thought, but it is the more important half,
the inward operation by which the mind gets itself formed so that it can
entertain a reference to objective reality. The rhythmic pattern, a presenta-
tional symbol, projects a sentience and then words, the discursive symbols,
complete the thought by filling the sentience with references to the real
world.

Such a presentational symbol helped me recently to understand a
point that a friend made in conversation. The neighborhood where this
friend and I both live is a flood plain, a low-lying, marshy tract of ground

crisscrossed by brooks and creeks. Storm sewers empty into the principal creek, and once during a flood the city fathers closed these sewers, thinking that otherwise the high level of the creek would force water back through them and into people's basements. Just the opposite would happen, my friend assured me, because even at flood level, "the flow of the creek would suck the water out of the sewer pipes." Those words in quotation marks are not my friend's; they are mine. Impatient with the excitement of making the discovery all by myself, I couldn't help interrupting. Well, where did I get the thought that allowed me to complete my friend's argument? Not from a physics course; I've never had one. Not from my high school chemistry, where my achievement was ignominious, nor yet from my two years of high school math, where I received somewhat higher grades indeed but learned no more than any circus animal that jumps to the crack of a whip. It's a pretty good guess that the impulse which rushed up in my mind was encapsulated in an artwork and that it was released—just as with Kopkind—when it fitted and completed the mental construct that I was trying to form at the time. I cannot recall the artwork in which it originated (if indeed it was an art object and not some other kind of attending experience). It may have been the pitch of a roof in a house by Frank Lloyd Wright, adjacent spots of color in a painting by Matisse, a line of a poem by Marianne Moore, a modulation in a Mahler symphony. Who knows? At any rate, one thing is sure, and that is that it did not arise from a moment in a professional wrestling match, the façade of a fast food restaurant, or an episode of a television soap opera. Substantial thoughts only issue from attending experiences that are worth undergoing.

A main point of this book is that the notion of rationality as an operation of two types of symbol helpfully complements the contemporary psychological explanation of learning as an interaction of intellectual skills and cognitive strategies. The two outlooks are not identical by any means, but the notion of reason as a product of symbolization makes the development of cognitive strategies more clear. Seen from the standpoint given in this book, these strategies begin as the ability of steadily contemplating a thing (attention), advance to assigning that thing a cue that will consistently recall it to mind even when it is not physically present (formulation), then go on to conveying an idea of that thing to others (communication), and finally achieve the crowning rational acts of propounding, analyzing, and arguing (reason). Normal intellectual development from childhood to maturity follows a pattern of gradually increasing mental adaptation of mental activity to reality. Learners become more effectual in their use of symbols as they go forward from the early period of merely noticing phenomena to the ultimate stage of explaining them and deliberately using them.

The central dynamism of this progress is the ever increasing complexity in the symbolic forms as they evolve upwards. At the base of this development is the mere random fantasizing of night dreams and daydreams, which precede the more reality-directed envisagements of life pro-

cesses. The still more disciplined symbolic forms of ritual and art embody the various powers that together go by the name of *imagination*, and from this origin develops language, which at one level is still presentational because through metaphor it flexuously expands and modifies ideas but which at another level becomes discursive—is the real beginning of discourse in fact—because it coordinates different psychic states with particular external realities. Once a person has attained language, the hinge between the inward connotation of ideas and the outward denotation of them, that person can go on to controlled, deliberate thought and its fruits: logic, mathematics, all the sciences. As mental development increases in complexity, it becomes less private and more social. The fantasies and life envisagements through which we first seize reality at the levels of attending to phenomena and storing them in our minds can be essentially personal, eccentric even, and the differences in our dreams and in our apprehensions of rituals and artworks show much variety among people at that level. But language, when it performs its higher function, requires a fully ordered community, and the products of language—all the operations that we call *reason*—cannot arise apart from a social milieu. (Perhaps this fact explains why it is that plugging students into learning machines or computers can never supplant seminars and the discussion techniques that emphasize the socially interactive aspect of learning.) The ultimate validation of our own thought is our success in persuading others to accept that thought.

Art is a central agent in leading the mind upwards from the solipsism of private fantasy to the realism of full-fledged thought. One way that art leads to higher mental life is by provoking intense, prolonged attention. At the lower level of fantasy, mental action is so weak and fugitive as to leave only slight traces or none at all, as with dreams that we know we have had but cannot remember or, at the slightly higher level of life envisagement, those situations of *déjà vu* when we can only vaguely recall the penumbra of some earlier state of mind. But, as we saw in Chapter One, the experience of art is object-rapt, an experience that imperiously pulls our psychic lives outside ourselves, fixes our attention on the other-than-self, the not-me, and thus rehearses us in the subordination of ego to environment which reason demands. Moreover, art provides an object which not only fixes attention but which also invites inspection. At the museum our fingers itch to feel shapes and surfaces, in the garden our eyes feast on colors and masses, in the concert hall we strain to hear every slightest variation of pitch and dynamics. Our conscious study of these richly varied sensuous surfaces anticipates that close analysis of the interrelations of words and meanings that will eventually go into reasoned discourse. Finally, art is the point in the ascending pyramid of symbolic activities at which a haphazard collection of people organizes itself into artists on the one hand and audience on the other, a separation which prepares for the still more subtle divisions of speaker/listener relationships and of dialectical reasoning. Community is essential to art, language, and reason, all three, but it makes its earliest appearance in the experience of art.

FOOTNOTES

[1]Robert M. Gagné, *The Conditions of Learning and the Theory of Instruction*, 4th ed. (1965, 1970,1977; Fort Worth: Holt, Rinehart and Winston, 1985). Subsequent page references, included parenthetically in the text, are to the fourth edition.

[2]And yet this point, which was clear in the earlier editions of the work, is obscured in the fourth edition, where Gagné slides over the subject of language as a system of symbols.

[3]George Lakoff and Mark Johnson, *Metaphors We Live By* (Chicago: University of Chicago Press, 1980).

[4]I derive this phrase from B. F. Skinner, *Beyond Freedom and Dignity* (New York: Alfred A. Knopf, 1971), 191: "...a small part of the universe is enclosed within a human skin."

[5][Andrew Kopkind], "Medium Gains," *The Nation* 7 (3 October 1987): 327-328.

PART TWO

CHAPTER SIX

The Place of Art in the Life of the Mind

Snobbery and Indifference

If art experience can confer the benefits that I have claimed, then what place should art occupy in our lives and how should we deal with it? More exactly, how good must art be in order to enhance our mentality, how much of it should we have, how various in kind should it be, how much time and energy should we give to it? These, I think, are the central issues that adults must resolve for themselves if they are to use art to sustain their own minds and to invigorate the minds of their children or students.

The easiest of these questions to answer concerns the quantity of art which an active mental life requires. The practical answer is that with respect to sheer amount far more than enough art already exists in nearly everyone's life to perform the main functions that art fulfills. So it is not more art that most of us need. Rather it is, perhaps, better art and, certainly, more intense attention given to that art. If it seems dubious to suggest that most people already have a large amount of art experience in their lives, the reason is that in ordinary usage the word *art* is equivocal. On the one hand it can mean classic high art, such major triumphs of creative genius as the Taj Mahal or *War and Peace*. But on the other hand it can also refer to all the extremely various objects which evoke an aesthetic response, the sort of experience described in Chapter One. Just the major categories alone are numerous; even omitting the generic forms of painting, literature, and so on, there remain the divisions of classic high art, religious art, popular art, folk or ethnic art, art for children, experimental art, and the huge field of applied art. And then the qualitative distinctions of good and bad art crisscross all the categories, for certainly there are plenty of failed attempts at classic high art hanging on motel walls (and in art galleries for that matter) and plenty of examples of good religious architecture standing in isolated villages. Taking into account all these varieties and levels of art, then, we see that just in the ordinary course of things we come in contact with so much of it that art *quantity* is simply not a problem.

The real problem for most of us is finding art of the right kind, the kind that advances mental life. In this connection, two opposite faults are possible. The one fault is snobbery, which exclusively associates art with morbid refinement of sensibility and thus constantly lays down eccentric laws for what is good enough. The opposite extreme to snobbery is aesthetic indifference, the lazy assumption that every art object is just as valuable as every other and that anyone's experience is as good as anyone else's. The ready availability of art in our lives can lead us to indifference by desensitizing us to aesthetic quality so that we begin to be satisfied by any music we get when the lawyer's secretary puts us on hold or any soap opera we watch while polishing shoes or preparing a meal. Once satisfied with bad art, we may become habituated to a careless artistic attending that is all right for dealing with most of our affairs but which guarantees that we shall gain little from our aesthetic experiences. If we go downhill far enough, we end up watching *Oedipus Rex* as if it were "General Hospital" and listening to *The Messiah* as if it were an ad for automobiles.

Snobbery is wrong because it brackets art with mere elegance and refinement, admirable qualities perhaps but not educationally significant. Indifference is wrong because it scants the disciplined strenuousness which must enter into important art experience. People who lead a good art life will be neither snobbish nor indifferent. Instead, they will sustain a continuous and ardent attending of artworks which are worthy of serious contemplation. If we see now what is the right kind of attending, we can go on to decide which artworks deserve our study.

Good Attending

In Chapter One the experience of an artwork was seen as an extreme case of object-raptness, of an audience's sense of being pulled out of itself and into the object and leading its life there as the object arrests the attention, fixes and prolongs it, shapes it, and then finally concludes it, releasing the audience back into the ordinary course of existence. When we examine our own experiences of object-raptness, we find that they are marked by three characteristics: intensity, abundance, and order. A few points should be made about each of these.

Intensity is the feverish excitement that artworks often arouse in us, or when not excitement exactly, then the quieter but still gripping engagement which concentrates our attention just on them alone and makes us nearly oblivious of all else. It is the wrenching away from our regular affairs, the beneficial disorientation which for the time being obliterates our practical worries, expectations, and obligations. In their dealings with art children noticeably display this characteristic, as Katie did even when a baby in her ecstatic entrance into the colors and shapes of her toys and the sounds of songs and nursery rhymes.

Abundance is the audience's perceptual acuity in gathering up and holding in mind every important feature of the work that makes it just the singular object that it is and none other—the degree of softness, enclosingness, and comfort in a sculpture by Henry Moore and the contrasting harshness and exposure in a statue by Giacometti. More than one attending of a work may be necessary in order to attain an abundant apprehension of it. People seem to differ from one another in the ease with which they take in complex works, possibly because some people are more familiar than others with the techniques for producing certain art forms. But not even the professional dancer will recognize on a first viewing all the expressive subtlety of Balanchine's *Agon* or *Concerto Barocco*, and it is well known that accomplished conductors grow over their lifetimes in their understanding of the music which they choose to perform.

Order has to do with the control which the artwork exerts on the audience so that beholders perceive just what is really there to be seen or heard (virtualities as well as measurable phenomena) and do not deform it with fantasies of their own. This characteristic of order seems to be the most difficult condition for audiences to fulfill. Many obstacles arise. One is that the surface which the art *object* displays to us and which we, in turn, constitute into the art*work* may itself be distorted. This distortion can come about in various ways. The Parthenon, once reposing in sparkling serenity atop the Acropolis, is now a dilapidated wreck. Performance works are especially at risk. Such ballets as *Giselle* and *Swan Lake* cannot now be mounted with perfect fidelity to their creators' intentions because the earliest presentations of those works are no longer known in detail. And the concert music of the nineteenth century and earlier cannot be performed exactly as originally given because the musical scores do not precisely dictate tempos, accents, and dynamics.

But far greater depredations on artworks are the damages which audiences inflict through careless observation and self-indulgent fantasy. Shakespeare tells us that Hamlet is thirty and overweight—Queen Gertrude says "fat" (Act V, scene ii, line 287)—but we will not accept Shakespeare's presentation of an adult responsible for his own behavior and instead transform Hamlet into a pathetic adolescent like Romeo, a hapless victim. Thus we reject the difficult but rewarding experience which Shakespeare has prepared and substitute a very different story about the fickleness of fate and the sorrows of young love. Music is not safe either from this sentimental smoothing over that guards our feelings against any shock from the artwork. Musical arrangers know how to pander to laziness. They have vandalized Tchaikovsky's music more than any other composer's, but lately Beethoven has also suffered at the hands of the popularizers; the noble main theme of his Ninth Symphony's fourth movement has been brutally jazzed up in a parody of the original, and the coda of his Seventh has been frenetically accelerated in an advertisement for natural gas. Architecture has shared in the general sweetening. I live in a community where for the last ten years a considerable amount of build-

ing has gone on, both houses and much larger structures, and the bad buildings—whose style now blends a blockhouse obviousness of structure with rococo ornamentation—go up along with the fine. The architects cannot claim economy as an excuse. These bad buildings are not really cheaper than the good ones; they merely look cheap.

Achieving the characteristics of intensity, order, and abundance in attending an artwork requires a special discipline. Helping young people to learn that discipline will be a subject for Chapter Eight, but here a few general comments can be made on the topic of attending to art. Some common sense guides are pretty obvious. In the case of performance works, we ought to arrive at the theater well before the beginning of the program in order to compose ourselves for reception of the work. As much as possible, we should avoid distractions, which we can do by clearing away practical problems from our lives, private fantasies, and the little physical annoyances that almost inevitably enter into any milieu, even the controlled environment of a theater or gallery. Whenever distraction does occur, we should turn away from it and contemplate with renewed vigor the object before us. And certainly we should not behave so as to be a distraction to others. What about boredom? How should we deal with it? The answer, I think, is that after we have tried to apprehend a particular artwork or even a whole genre and have not had success, then we should turn away from it for a time and try something else. Suppose you find that you cannot engage yourself with Verdi's *Traviata* or *Aida*. No matter. Maybe you should try Wagner, or opera may just not be your *métier*. So the conclusion seems to be that the sheer amount of art is less important for the growth of our minds than the character of our attending, and it is also less important than the quality of the art.

How Good Does Art Have to Be?

For the sake of concision, my immediate answer will take a somewhat arbitrary form, and then qualifications and reservations can be made later after the essential points have been stated. In order to improve our minds the art we use has got to be good enough either that it presents a mode of consciousness that we do not already possess (novelty) or that it projects for us some abiding pattern of life process (vivacity) or that it reminds us of the seriousness of being alive and human (gravity). Now, some comments. First, it is clear that I derive this prescription of good art from the definition of bad art which appears in Chapter Four. Next, as I tried to emphasize in that chapter through my illustrations, I do not by any means confine the idea of good art to the category of high classic art. The idea of good art goes far beyond classic art to embrace traditional crafts of good design such as quilts, crocks, and wooden implements which used to be common enough but which are now collectors' items. It includes such urban housing developments as are really fit to live in as well as small town

churches and country barns. It certainly includes some substantial portion of the field of popular art that burgeons in the record store, on the radio, and even—with large subtractions for obviousness and lowness—on television. And of course it includes much more besides.

I do not mean that all artworks are of equal merit, nor do I doubt that capable critics within a field of art can distinguish the works in that field which really are pre-eminently valuable. I simply claim that artworks which are relatively good-for-you or good-for-me need not be among the absolutely best of their kind. I can illustrate this point by referring to some artistic predilections of my own that cover a fairly wide range of quality. Two magnificent Cézannes, both landscapes that hang in the Albright-Knox Museum in Buffalo, New York, have done for my mind all that artworks can, haunting it with those ghosts of connotation that seek embodiment—denotation—in the world of things. I can imagine an art critic saying, "Well, that's no wonder; Cézanne has that effect on most of us, which has to do with his being a great artist." But now to mention a third painting, of less note than the Cézannes. Along with about a dozen other works by the same artist, it is housed in a favorite restaurant of mine outside Buffalo. I go there for the excellent food but also to look at this one painting. This artist's work strikes me in general as pleasing in an academic, almost pedantic, way but not particularly striking or memorable. There is the one exception, however: a small watercolor showing a mass of violets surrounded by their green leaves. Both colors are soft pastels, the whole bunch seeming to rise off the paper with the leaves a little behind the blossoms and supporting them. For me it is a gracious presentation of one particular way to possess one's own life, a way that is at once modest but also various and confident. Now, since this painting does so much for me, is it therefore on a level with the two Cézannes? I believe that the answer is no and that a good critic of painting could give persuasive reasons for that answer. All the same, the painting of the violets is quite good enough to enrich this viewer's mind, and it may perform the same service for others. My point is that out of the immense number of artworks that deserve an audience, each of us will be attuned to a few of the very great ones, from which throughout the rest of our lives we shall take immeasurable and continuing profit, and we shall also discover affinity for many more works of the second and third range of achievement, from which we shall benefit considerably. At this level of quality I do not need to discriminate. I can fill my glass from the major artist's vat or the minor artist's pail. It's all one to me.

The logical consequence of these observations is that no canon can be established, no set of artworks listed, that everyone should necessarily experience. This is so partly because of the enormous extent and variety of eligible works, which we have already seen are so numerous as to be in effect countless. In addition, the many variables in the situations of different art lovers militate against forming any one list of mandatory works. Differences of age, temperament, education, geographical location, and financial

resources all play a part in determining what use anyone can make of a particular artwork. Thus it is that a good art life does not, like a reducing diet or a course in double entry bookkeeping, have to doggedly follow a syllabus which someone else has made for us. Instead, guided only by the quite sufficient principle that artworks are good enough for us if they present to us the novel, the vivid, or the grave, we can range freely in the endless field of art, each of us independently finding works and confident that the ones which we voluntarily enter into repeatedly and deeply are the right ones for us.

A good art life does not consist of running through checklists of major works. Instead, it is far more likely to spring from lucky occurrences that seem to happen almost by chance. We go to our local museum, for instance, and we see a painting by Mondrian that grips our interest so powerfully that we return to it again and again, we pick up some reproductions of his paintings in the museum's book shop, we visit a leading museum in a major city especially to look at the Mondrians when we go there on a business trip, and we borrow or buy more books on this artist. Or perhaps Bruckner's Ninth Symphony is played on the FM station, and for the first time, on account of some such accident as a commentator's helpful remark or just happening to hear the wonderful lullaby that concludes the work, we penetrate Bruckner's prolixities, repetitions, and heaviness to get a sense of his essential greatness, his special stability and serenity. We are so taken by this composer that, as with Mondrian, we try to deepen the acquaintance. Depending on our finances, we obtain records either by borrowing them from the library or by purchasing them outright. We listen to them repeatedly, going back to listen once more to the passages which on first, second, and even later hearings we cannot fully grasp. We read on a record jacket of the relation of Bruckner's music to Mahler's, and we begin listening to one and then the other to discern the special character of each. We listen to the conductor Bruno Walter's searching versions of these artists' works and compare those versions to Klemperer's equally great but decidedly different renderings. Thus, a good art life is not a matter of doing what others say is good for us, a forming of superficial acquaintance with the items on someone else's list. Rather, it is a moving ever more deeply into the works which most powerfully attract us.

In making this point that a good art life is not based on a list of approved works, I do not want to put myself in opposition to the ideas which E. D. Hirsch, Jr., expresses in *Cultural Literacy*,[1] for he and I are concerned with quite different things. To Hirsch the value of his extensive list (five thousand items) of dates, persons, sayings, conceptions, places, artworks, and political movements is that it summarizes some part of the common knowledge of the greater number of educated people. Thus, Hirsch's list is enabling; it helps those who become familiar with its contents to enter into a community of like-minded persons and, on the basis of shared knowledge, to communicate with them. Although that strikes me as both a useful and high-minded objective, it is not by any means what I have in mind

when I recommend the active pursuit of an art life. In this book I am interested in art because I regard it, along with language, as the chief underpinning of mind. Hirsch, dealing with the upper end of intellectual life, focuses on the communication of ideas. I, on the other hand, focus on their formation.

Must We Agree with Others?

Does it matter that different persons in the same audience make different judgments about the same artwork? First, I'll answer the question in a few words and then, since it poses some intriguing and important problems, I'll respond to it more fully. Briefly, then, I do not think that there is necessarily an intellectual loss to either party when two people disagree in their judgments about an artwork. Furthermore, I think that—apart from such obvious physical features as size, colors, and shapes in the case of painting or length, dynamics, and tempo in the case of music—different people's assessments of the same artwork will almost certainly diverge from each other on fairly salient points.

One problem posed by this question about the reliability of aesthetic judgments is the degree to which we should seek to be independent in our thinking about art or, indeed, anything else. Since this subject seems generally to elicit confused and platitudinous comment, it is good to have Matthew Arnold's story about Mrs. Shelley to keep us straight in our thinking. Here is the opening paragraph from Arnold's essay "Shelley."

Nowadays all things appear in print sooner or later; but I have heard from a lady who knew Mrs. Shelley a story of her which, so far as I know, has not appeared in print hitherto. Mrs. Shelley was choosing a school for her son, and asked the advice of this lady, who gave for advice—to use her own words to me—"Just the sort of banality, you know, one does come out with: Oh, send him somewhere where they will teach him to think for himself!" I have had far too long a training as a school inspector to presume to call an utterance of this kind a *banality*; however, it is not on this advice that I now wish to lay stress, but upon Mrs. Shelley's reply to it. Mrs. Shelley answered: "Teach him to think for himself? Oh, my God, teach him rather to think like other people!"[2]

In their different ways both Mrs. Shelley and the lady are right. Mrs. Shelley is right that we should learn to think like other people—exactly like other people—on such subjects as the location of Japan, the periodic table of elements in chemistry, or the rules of evidence in logic. Obviously, the greater part of our thinking uses information and procedures that have been given to us by others, and such thinking *should* be like other people's in order to be accurate. On the other hand, the lady is right that we

should learn to think for ourselves, at least some of the time. The instances just given of thinking like other people will likewise illustrate that we must think for ourselves as well. Of course all the students in a chemistry class should have the identical knowledge of the periodic table of elements, but they will not go far in chemistry unless they think for themselves and understand why it is a table at all and what is being periodicized. Certainly we should think for ourselves when we are placed in personal difficulties that are not just like other people's. If we are researchers or theorists, we may be able to improve dramatically the knowledge or practice in our field by thinking for ourselves. And as students, if we are to get beyond low-level rote learning, we must independently work through newly presented ideas so as really to possess them and put them to productive use, as in the case of the chemistry students. One part of our thinking is formulas taken on trust, but another part is our own discovery gained through solving problems on our own.

In our art lives we think like others, but we also think for ourselves. As for thinking like others, we use a great amount of received information which helps us to attend correctly to any particular artwork. For instance, in spite of being a near musical illiterate, I can pretty confidently predict certain features of music I am about to hear on FM radio just as soon as the announcer says that it is a symphony. I know that the music is going to be relatively long, almost certainly will be divided into parts (most likely four) of different tempos and perhaps tonalities, will be played by many instruments, and will possess an unusually complex organization of themes. This knowledge—all of which I have learned from other people—will give me the proper mind-set for hearing the music. It will warn me, for instance, that I cannot listen to this music in the relaxed, half-serious way that I would listen to a march by Souza or an overture by Offenbach. I also think like other people when I read the notes on a record jacket or the program booklet of a concert. Our attending to artworks is much helped by those fine critics and commentators who have the knack for saying just those things about an artwork or an art form which will help audiences attend acutely to the most signal features. The field of literature is served by many of these intermediaries between the work and the audience. Generations of college students have been heavily and beneficially affected by Cleanth Brooks and Robert Penn Warren in their series of commentaries beginning with *Understanding Poetry*[3] and by Lawrence Perrine in his *Sound and Sense*.[4] In the literary column which he wrote many years for the *New Yorker* Edmund Wilson was able to impart his ample learning and his wide interests to readers who were not literary specialists. In the field of dance, Edwin Denby wrote wonderfully evocative criticism that required no technical balletic knowledge to understand,[5] and more recently in the *New Yorker* Arlene Croce has carried on Denby's work. In music, non-specialists owe much to Karl Haas, whose program over national public radio gives detailed but intelligible commentary, and Pauline Kael's essays about film fortify and enrich our understanding of that art.[6] These are the "other

people" we try to think like when we engage with any of the arts which they write or talk about, for we know that through their teaching we can perceive aspects of artworks which, without such help, would be invisible to us.

On the other hand, our experience also teaches us that our apprehending of art involves thinking for ourselves. One strong evidence on this point is that we do not by any means follow an external standard in deciding what artworks and what artists we do or do not like. "No man," Samuel Johnson said, "is a hypocrite in his pleasures,"[7] and our behavior verifies his observation. If we like musical comedy, we go; if we don't like it, we don't go. But sometimes we change our minds, which is another evidence that we are thinking for ourselves. On early acquaintance we may not accept an artist who, after long exposure, greatly pleases us. Or, as fairly often happens, our first encounter with an artwork may lead to nothing but a perceptual blur from which the work barely emerges, but then, as we continue to engage with it, its form becomes clear to us and we welcome it with delight. In these dealings with artworks—judging that we like or dislike a work or coming finally to a vivid perception of what was formerly blank—we act wholly for ourselves. No one else can appreciate anything for us, and it would be hard to name any other sphere of mental action in which we are as self-sufficient, as free, as we are in the realm of aesthetic experience.

The Fallacy of Objective Knowledge

In this discussion of differing apprehensions of the same artwork by various members of the audience a commonly made distinction needs to be exploded. It is the distinction—totally false and completely confusing— that is often mistakenly drawn between objective and subjective knowledge. All knowledge is subjective. There is no other kind. Knowledge is a mental state in someone (the *subject* of knowledge) about something (the *object* of knowledge). This last statement is true as it stands, but if we want to complicate it a bit we can go on to point out that subjects of knowledge (people, knowers) can at the same time be objects of knowledge when anyone knows anything about them. But the basic point is that all knowledge is subjective, a mental state that a person entertains concerning something. One mischief in the false disjunction between subjective and objective knowledge is its implication that some knowledge—generally called "objective"—is so grounded in facts that it is unlikely to be false and that other knowledge—"subjective"—is so much based on the high-strung feelings of flighty dilettantes as to be nugatory. But knowledge is not more or less objective; it is more or less certain, which is an entirely different thing. The only knowledge which is absolutely certain, about which we can have no doubt whatever, is faith, and that is not intellectual at all finally, a product of thought, but rather an act of will, like Don Quixote's

conviction that his beloved Dulcinea is chaste. The degree of certainty which we can have in our knowledge depends on the conditions of knowing, and these conditions change constantly, for individuals as well as for disciplines and communities. They can improve, or they can degenerate. They are different for persons who have more or less experience of a subject. For example, some people—doctors—are in a position to have more certain knowledge about health than others. And some—critics—are in a position to have more certain knowledge about artworks. But neither doctors nor critics can be absolutely certain in their knowledge. The point is that art lovers who cannot be completely sure just what an artwork imports are in exactly the same condition as everyone else in the world, excepting only those fanatics who cannot conceive of themselves as being wrong about anything.

So, then, I conclude that two intelligent persons in an audience may well perceive the same artwork differently and thus be said to have different knowledge of it. One of the persons may have heard something about the work which the other person has not heard, or one may be physically situated more advantageously for proper seeing or hearing, or one person but not the other may have just undergone some experience that happens to attune that person to that particular work. Or other reasons may be involved. I do not think that the difference in reception matters much as long as both persons receive from an artwork an impression *which they would not have spontaneously created for themselves.* Obviously, the successful reception of an artwork involves concentrated mental activity. Still, fundamentally, the artwork that we contemplate must be the artist's creation, not ours, if it is to do us any important good, for if artworks merely reflect our own psyches back to us, then they give us nothing new. Rather than adding to our stock of ways to perceive reality and deal with it, they become jailers that help to confine us to the dungeon of our own particular consciousness. As the very template of valuable mental operations which we can employ if we choose, an artwork, properly attended, can free us from that dungeon. So when we insist on the otherness of an artwork, when we see in *Crime and Punishment* or Chartres Cathedral a thing that we would never have made had the project been ours, then we have the representation of a new state of consciousness that we can absorb into our own mental repertoire, an opportunity for discovery and growth.

Summing Up

The first part of this book argued that the experience of art contributes importantly to mental development. This second part goes on to explore the practical implications of this doctrine for ourselves in our private lives, for school-wide programs, and for teachers working with students in the classroom. What we have had to say in this chapter about art in our own lives boils down to these main points: (1) Already there is a

large *quantity* of art in our lives, and so the practical question for us is not acquiring still more art but rather attending to art in a better way and, perhaps, getting better art. (2) The right, productive attending of artworks has the characteristics of intensity, abundance, and order, qualities of experience which arise because we allow ourselves to be wholly absorbed in the object we contemplate. (3) Art which is good enough to improve our minds does not have to be in the high classic tradition, nor does it have to be absolutely the best of its kind. It does its proper work if it projects to us unfamiliar states of consciousness or sensitizes us to life processes or teaches us respect for living things, all illuminations of the mind which are the basis of reason rather than its outcome.

FOOTNOTES

[1]E. D. Hirsch, Jr., *Cultural Literacy: What Every American Needs to Know*, Vintage Books Edition (New York: Random House, 1988).

[2]Matthew Arnold, "Shelley," *The Complete Prose Works of Matthew Arnold*, ed. R. H. Super (Ann Arbor: University of Michigan Press, 1977), 11: 305.

[3]Cleanth Brooks and Robert Penn Warren, *Understanding Poetry* (1938; New York: Holt, Rinehart and Winston, 1976).

[4]Lawrence Perrine, *Sound and Sense: An Introduction to Poetry*, 7th ed. (New York: Harcourt, Brace, and Janovich, 1987).

[5]Edwin Denby, *Dancers, Buildings, and People in the Streets* (1965) and *Looking at the Dance* (1968), both published in New York by Horizon Press.

[6]Pauline Kael, *5001 Nights at the Movies: A Guide from A to Z* (New York: Holt, Rinehart and Winston, 1982) and *Hooked* (New York: Dutton, 1989).

[7]James Boswell, *The Life of Samuel Johnson, LL.D.*, Edited by R. W. Chapman, Oxford Standard Authors (London: Oxford University Press, 1953), 1309.

CHAPTER SEVEN

Art in the School

The Aesthetic Education Coordinator

In this chapter on school-wide aesthetic education programs my aim is to be practical and specific. I shall begin with a concrete suggestion, the most important one I shall offer, the one which will make possible the other suggestions given here. It is for each school to appoint one particular teacher as aesthetic education coordinator and to arrange released time for this teacher to supervise the school's program in aesthetic education. The justification for such an appointment—and for the released time it entails—will become very obvious as we run through the features that should mark the program and that would have to be overseen by the coordinator, but just now I shall give a particular reason which my own experience has made painfully evident to me. I belong to an arts-in-education organization, Young Audiences of Western New York, which sends performing artists into the schools to give concerts. In Young Audiences we recognize the educational limitations of the one-shot program, standing alone and isolated from the work of the students in regular classes; we realize that such a program, without either preparation or follow-up, is in danger of becoming nothing but a mere divertissement from the serious business of the school day, an idle amusement. In order to overcome this weakness and to make our programs educationally relevant, we have prepared curriculum material for each of them, material listing suitable educational goals, pre-concert and post-concert activities, related academic subject matter, and such sources of additional material as bibliographies and discographies. When teachers see this material, as for instance in the workshops on aesthetic education where I distribute it, they say that they would like to use it and complain that they have never heard of it before. In fact, though, a week or ten days before a group performs in a school, Young Audiences sends out to the school principal the curriculum material pertaining to that group. I do not wish to blame the principals, who, after all, have plenty of other duties to distract them. My point is that we would be able to avoid the bottleneck if we could send the material to a teacher, a coordinator, responsible for handing it out to colleagues.

A major project of this coordinator should be maintaining an up-to-date inventory of arts resources that can be made available to teachers and their classes in a particular school. Large cities and their suburbs afford a

wide choice of opportunities in art, of course, but schools in quite small and out-of-the-way places may also be close to fine and distinctive artworks. For example, about thirty miles east of Buffalo, New York, is a town of six thousand called Medina, remarkable for a number of houses and public buildings constructed either of cobblestones or a pink-to-gray limestone locally called Medina stone. The cobblestones, each about the size of a fist and rounded into the shape of a fat discus, are inserted into mortar, often in several rows of stones tilted at one angle and then several more rows tilted at the opposite angle in a sort of herringbone or some other pattern. These highly textured outer walls give the houses an extremely active, even vivacious, feeling. The Medina stone leads to a different effect. Cut evenly into large symmetrical blocks that fit closely together, this material lends itself to the construction of generously scaled buildings with high ceilings and correspondingly tall windows and doorways, real edifices that stand out and assert themselves. The builders of these places and those who employed them liked a style of architecture that projects lifelike qualities and even personal, moral characteristics. These buildings have fronts and backs and sides, hold themselves confidently, enjoy a serene repose, and, in the case of the cobblestone structures, laugh contentedly. There are sermons in these stones. If I were teaching in Medina I would not fail to offer my students a unit in local domestic and civic architecture, and I would emphasize the noble style which builders in that small city achieved more than a century ago. But although Medina possesses an outstanding artistic heritage, it is by no means unique in containing valuable art. Wherever and whenever humans progress towards truer, finer, or more useful conceptions, as an early step in that advance they will create art forms which project the newly dawning mental processes and the emerging possibilities of the life of the mind. A good program of aesthetic education in any particular school will draw from the immediate vicinity the artistic evidence of significant mental life that has gone before or that is happening even at the moment.

The aesthetic education coordinator should also catalogue the human resources which are locally available. Some are artists—poets, musicians, dancers, craftspeople—and others are life-long arts lovers who through passionate study have acquainted themselves with the work of a major artist or with such indigenous art forms as Indian artifacts in one part of the country or glassware in some other part. Such people may not be good teachers; they may not even be effective speakers. But nonetheless aesthetic education programs guided by an alert teacher/coordinator can make use of these resources and turn them to good account, perhaps by using them as subjects for interviews in students' projects, perhaps for demonstrations in the classroom, perhaps for the loan of art material to the school. Sometimes these resource persons possess information that would interest a wider audience than a particular class or school, and they can become the basis of oral history projects or other scholarly efforts. I ran into such a person a long time ago when I began having my income tax returns made out by a professional accountant. At first he struck me only as

a well educated but garrulous old man with literary tastes. But at one of our annual meetings over my tax report he told me of a time in his early manhood when one of his companions was F. Scott Fitzgerald, and he mentioned that in their talks Fitzgerald would often confide a fantasy of inheriting a very large fortune. This is an illuminating reminiscence about the author of *The Great Gatsby* and other tales in which money is so important. I wish that I had cultivated this acquaintance, but it is too late now, for the accountant has since died, probably taking with him a fair amount of information concerning Fitzgerald's time in Buffalo.

In addition to these human resources the coordinator should survey the institutional helps through which the school's aesthetic education program can be enhanced. Of course the coordinator will become familiar with any film holdings or record or video collections owned by the school district and, through the district, larger collections obtainable from the state education department or some other educational agency. The public library system can be a mine of music recordings, art slides, and art books, and nearby museums of art and history may be able to put on programs in the school. Often a school will find itself within commuting distance of various arts performance groups—small dance companies, theater groups, chamber music and folk music groups—which can offer performances either at their own regular theater or inside the school building itself. A word of caution should be said about these performance groups. Both artistically and educationally they represent different levels of quality, and not all of them are by any means good enough to offer programs in schools. It would be a pity if students were turned off from art simply because they were exposed to bad performances or to presentations unsuitable to their level of development. So another very important duty is imposed on the coordinator, who must not only survey arts resources but also must evaluate them for both their educational and artistic merit.

The coordinator will want to be familiar with the main organizations which support the arts-in-education movement. These organizations include the Alliance for Arts Education, the National Endowment for the Arts and (in some of its activities) the National Endowment for the Humanities, and state and local arts councils. Some of these organizations are fully and explicitly dedicated to art in education; others, like the two National Endowments, have wider commitments and only a circumscribed interest in the schools. Organizations which offer specific programs for schools include Young Audiences, with thirty-seven chapters nation-wide, the Lincoln Center Institute and its off-shoots in various communities, and the Getty Foundation.[1] Even though these organizations have carefully conceptualized the educational component of their programs and have taken care to insure artistic quality of their performances, they obviously cannot deliver a complete aesthetic education program or even unit to each individual school. Fairly big changes in programming and approach will have to be made as a group of percussionists, for instance, performs first for an

elementary school audience, then for a middle school, and finally for a high school.

Thus, if schools are going to have vital programs in aesthetic education, programs to enhance the mental lives of students, then those programs will have to be planned by aesthetic education coordinators. The main qualifications for coordinators can be deduced from the responsibilities just outlined. Coordinators are more likely to succeed if they have had at least a few years of teaching experience and also if they are familiar with the school where they will be working. Of course they should be interested in art and dedicated enough to one of the art forms to attend it often. They may be artists themselves, but being a practitioner is by no means an indispensable condition for serving well as a coordinator. In this instance loving art is far more a recommendation than practicing it. From my experience in offering courses and workshops in aesthetic education I can attest that many such teachers exist and that they could give valuable service and achieve professional fulfillment in this role.

Some General Principles

What should aesthetic education programs look like? What goals might they have that really could be achieved? How could the goals be fulfilled? These are the questions that coordinators will have to answer if they succeed in creating programs that will gain the respect of teachers, administrators, and parents. Obviously, I cannot here give definitive answers any more than outside cultural agencies can set up generic programs which will fit each one of all the different schools. What I can do, though, is point out some general principles that should guide the development of programs and leave to coordinators the task of adapting those principles to their own specific situations.

Specialists in aesthetic education seem to have reached a fairly close consensus on the question of the kinds of student activity that ought to constitute an effective program. Various aesthetic education programs may include more or fewer strands, and the strands may be called by different names. For instance, Harry S. Broudy[2] gives three elements, which he identifies as art performance, recognition of sensuous and formal properties, and understanding of the cultural values expressed in an artwork. The Getty Foundation's[3] program in art appreciation, on the other hand, lists the four strands of art criticism, art history, aesthetics, and performance. The model sponsored by Young Audiences[4] proposes two kinds of resource: activities, which include artists' performance and demonstration as well as students' participation; and concepts, which deal with artistic form, the artist's creativity, and reflections in artworks of the societies which helped to engender them. Certain elements are common to all these programs. They all aim to get students to learn information about the artwork that is

being experienced and perhaps about the genre which the work represents; all require overt activity on the part of the students, even to the point of themselves performing the art. Finally, the programs call for students to achieve some kind of knowledge beyond familiarity with the particular artwork itself. A summary of the present view about the components necessary to a good aesthetic education program would name the following elements: *apprehending* of the artwork in all its sensible qualities of color, sound, and so forth; either *performance* of the artwork (or of the art form represented by the work) or else active *participation* in it; *appreciation* of the artwork's implication of cultural values. Now we ought to go more deeply into each of these elements.

Apprehending is the intense and complicated mental activity which constitutes an artwork out of the data supplied and partially organized in an art object. When we apprehend artworks we are necessarily conscious of undertaking a highly energetic experience, of an extremely active back-and-forth movement of the mind as it partly receives, partly creates an object which is at one moment physically present, at another imagined, and, when most perfectly grasped, a blending of perception and imagination. Art objects only become artworks for us, things of value, when we accord them this close scrutiny and powerful empathy. Unlike ordinary, non-literary language, which is generalized, conventional, and paraphrasable, artworks exist for us only when they are specific, individualized, highly foregrounded in consciousness. When you are right in front of the Empire State Building, really looking at it in the way it deserves as an aesthetic object, it seizes you, overwhelms you, absorbs you. A miniature painting, if it is good, will have the same effect. They are not *about* something; they *are* something, embody something. Not so *The New York Times* or a State Department press release. The one kind of symbolism, art, makes its import available to us through intense experience of a particular concrete form, an experience of *apprehending*. The connection between ourselves and ordinary language, by contrast, is more generalized, and this connection is commonly called *knowledge*.

Since the apprehending of artworks is an energetic activity, something we really do, it seems probable that we can learn this activity through the *performance* of art or at least *participation* in it. If we could choose between actual performance and mere participation, we would prefer performance, for by knowing the details of an art form, by knowing exactly the way that a particular art object is made, we become more fully sensitized to that kind of art than we would otherwise be. Theodore Patricola, a doctoral student of mine, has done some research for his dissertation which seems very persuasive on this point. Originally Patricola set out to see if any difference exists between older (55+) viewers of visual art and viewers of high school age in the acuteness with which these two different groups recognize the details in a drawing or other graphic. He found no statistically significant difference between the groups in this respect; the very slight superiority of the younger group could have resulted from any

number of causes, not necessarily from the difference in age. When he realigned the subjects in his study, however, so as to compare those who had taken performance courses in visual arts with those who had not, he found that those who had taken the courses did better on a test of aesthetic perceptual acuity than those who had not and that this difference was indeed statistically significant. The conclusion appears to be that people who themselves have tried to make paintings, drawings, and photographs possess a finer discernment of these art forms than those who have had no such experience. The same thing is likely to be true of those who practice the other arts.

Unfortunately, none of us has the time to attempt to learn performance of all the major arts, and probably most of us lucky ones who acquire any art performance skill at all will have to confine ourselves to just one form of artistic expression. I doubt if there is any large scale transfer of sensibility from one art form to all the others. I doubt, for instance, that people who have studied the piano are for that reason better judges of architecture. Still, there are connections among the arts, and learning one art probably teaches certain aspects of some others. A dancer cannot go far without learning the elements of musical rhythm, the difference, for instance, between the ONE-two-three of a waltz and the ONE-TWO of a march or between the slower beats in the adagio that commences a *pas de deux* and the quick tempo of the allegro that concludes it. And to go back to the example of people who learn to play the piano, they certainly can tell if a dancer is musical or not. Moreover, anyone who has studied drawing should have a keen sense for the creation of illusions (as well as realities) of space in architecture and gardening.

Up to this point we have justified the learning of art performance with the argument that it increases a student's perceptiveness of whatever kind of art that student performs. So far so good, but an important caution should be added. Some students who are trained to *apprehend* an art may also come to desire to *practice* that art as well. No longer content to be lovers of art, literally amateurs, they want also to become performers of it, professionals. Just here lurks a danger. As was shown in the earlier part of this book, art *participation* is universal, a symbolic activity in which every human takes part in some form or other, probably in many forms. But the gift of art *performance* is by no means universal. To be a decent sculptor or dancer or architect depends on a number of chances, on being in the right place at the right time so as to come under the influence of a powerful teacher in the student's formative period, on having enough financial support to pay for good instruction and the leisure to profit from it, on the physical stamina that serious art performance requires, on ego strength to stand up to rough correction and downright rejection, on the mysterious readiness to produce art that goes by the names of *talent* and *genius*, in some arts on possessing special physical attributes. Somerset Maugham's depiction in *Of Human Bondage* of the failed painter who kills herself is fiction, but it is by no means fantastic. Any professional artist knows true

and cruel stories of lives that were ruined or at least badly damaged because art lovers mistakenly thought they stood a chance of becoming professional art producers. Art teachers in the schools must be on guard to warn students that the professions in art, though noble, are most often meanly rewarded and, even so, only open to a small minority of aspirants.

If we remember that the word *amateur* originally meant "one who loves," we shall have the right principle for deciding about the kind and amount of emphasis to put on arts performance in basic education. In his *Politics* (Book VIII, Chapter 6) Aristotle faced squarely the question how much musicianship should be taught to general, non-specialist students, and his answer was that since professional musicians are those who enter competitions for money, basic education in music should not reach that far. His answer suits our purpose exactly. When students learn about the performance side of art, their basic education is much advanced, but ordinary schools giving general education are not concerned to train professional artists, people who compete with each other and who earn a living by creating or performing art. Nearly all the major arts recruit performers from schools and studios offering intensive and highly specialized instruction. The only exception to this generalization which occurs to me is literature, whose practitioners come up through the common schools. Perhaps dramatic writing is another exception, but many playwrights and television writers seem to have served a kind of apprenticeship as actors or theatrical technicians.

Rarely will students have the chance to learn performance in more than one art, and so they must engage in participation in the other arts if they are to learn to attend to them as closely as possible. The next chapter describes methods that classroom teachers can use to intensify their students' participation, but here we shall examine the procedures that an entire school can employ. The most simple suggestion of all is for teachers at assembly programs to sit within their own class groups rather than at the back of the room or in the aisles. Seated amongst their own students, teachers control them at least as easily as they would if located away from the class, and in addition, when they are close to students they unobtrusively model acceptable behavior for attending an arts event. For instance, if we had to give formal instruction in words about correct audience behavior, we would probably say something like, "don't distract others, don't talk, don't pass notes, don't make noises or move about." But surely those prohibitions hardly give our real meaning. A theater or gallery is at bottom a place of entertainment, a place to be amused and entranced, not a place of confinement. Of course when we watch a comedy we laugh at a joke even if we are the only ones to catch it, we nod to a friend when a passage of music occurs that both of us know and love, at an exhibition of pictures we may whisper comments to each other, we may even hold hands. Formal description of correct behavior is certainly boring and perhaps even misleading, but direct enactment of intense, courteous attending is a clear and powerful teaching.

Another simple means to increase students' participation in art is to surround them with artwork which they themselves and their friends have created. Many schools regularly display in the hallways graphics produced by students in art classes. Generally, elementary schools show all students' work, and the schools which exhibit this work at the child's eye level rather than the adult's show that they are genuinely student-centered. Nearly everyone would agree, I think, that in the early elementary years all children's work should be displayed, for especially at that time in their lives children can grow importantly through making art and sharing it with others. Sooner or later, however, the realization must come that talent for art, like talent in the other main fields, is unequally distributed. I know a middle school which seems to deal well with this undoubted fact and yet does not wound its less artistically gifted students. That school keeps on permanent display in certain locations the very best art that has been produced there over the last two decades, but then shows in other locations a more general sampling of all the work that is currently being done. Thus the artistically gifted have their creative drive reinforced without any minimizing of the effort of less talented students. Similarly, schools and school systems that publish in well printed soft-bound editions the work of their best student writers are not being unduly elitist if at the same time they also give outlets to ordinary writers, such publications as class and school newspapers, yearbooks, and informal collections of writings that are mimeographed for parents or put up on bulletin boards. Such arrangements are merely the academic approximation of the division of sports into intramural and extramural levels.

But the production of art by students can only be a means and not the goal in an aesthetic education program, whose mission is to make wise art consumers rather than art producers. Through trying to produce art, students attain a fuller awareness of the particular qualities of professionally created artworks. By actually experiencing the growth of an art object that they themselves are creating or reproducing, by seeing it become infused with characteristics which they have designed for it and by still other features that arise by accident or by some necessity generated within the work itself, they acquire a keen perception of artworks not their own. They begin to constitute those artworks more fully and accurately and thus to glimpse formations and actions of consciousness which probably would not otherwise occur to them. So the principal content of the aesthetic education program ought to be professional, not student, artwork.

Just how good does that artwork have to be? Parts of the discussion in earlier chapters should help us to answer the question. In Chapter Four we saw that art can be either good or bad according to the states of consciousness which it expresses. We should add here that a somewhat different kind of badness—inexpressiveness—arises when, in the case of performed arts like music or drama, the technique of the performers is not adequate to convey the essential features of the artwork. No one wants to listen to a caterwauling soprano or to watch a flabby dancer. On the other

hand, as was pointed out in Chapter Six, the demand that art be good enough to fulfill its purpose of expression can be exaggerated into a morbid insistence on the flawlessly exquisite, an extreme of taste which has more to do with high fashion than with art.

We have also seen that beneficial art is not limited to the category of high classic art. Not just *La Bohème* and the ceiling of the Sistine Chapel will have art's good effects. So will popular dance tunes that deserve attention, well designed houses, and even, on occasion, greeting cards and television commercials. Once students learn intense aesthetic attending by practice with familiar forms of art, then they can go on to the high classic instances that demand more from the audience but also reward attention more richly.

When writers on aesthetic education deal with the *appreciation* of a culture's values which art can inspire in an audience, they have something else in mind than the presentational symbolism which in the first part of this book was taken as part of the basis for mental action. Rather, these writers are focusing on "myths of concern" as they are called by the literary critic Northrup Frye.[5] These myths teach the values which anyone has to know in order to thrive in a particular culture. In Chapter Two we glanced at myths of concern when we described the romantic kind of love which is implicit in much Western art since medieval times, and we saw another such myth when we mentioned the tender feelings about some species of animals which abound in American and British literature of the nineteenth and twentieth centuries. Religion, law, sport, civic ceremony, journalism, all these help to inculcate myths of concern, but art seems to be especially persuasive.

Sometimes these myths are so powerfully instilled as to grow into a kind of reason that contravenes logic itself, or at least utilitarian logic. For instance, the objective and unassailable fact is that infants and young children are nuisances on airplanes and other kinds of public transportation. If ticket prices were set by the amount of trouble a passenger gave, then children under seven certainly would have to pay a higher fare than ordinary tourist class travelers, who keep quiet, sit still, and refrain from making unseemly remarks on other occupants of the plane. Yet the logic of this ineluctable argument is thoroughly repugnant to nearly everyone. Where do we get such charitable tolerance for unpleasant behavior in the very young? Primarily from art. The notion of the preciousness of children is more likely to have originated in religious art than in religion proper, and of all great religious art, Raphael's paintings of Madonna and Child, through their pastel coloring and soft lines, most perfectly render the complex mental states which come together in this idea. The popular portraits of children and their mothers, both religious and secular, descend ultimately from Raphael and other old masters just as modern love songs derive from the troubadour poets, Petrarch, and Shakespeare. From Raphael to Mary Cassatt is one step, and from her to our contemporary illustrators of magazines

and greeting cards only one or two steps more. Thus the masterpieces are the source of lesser works, and the whole range from top to bottom makes up a completely exfoliated myth retold for different times and for audiences of different capability.

Some specialists in aesthetic education prize the appreciation of cultural values as the most important benefit that art has to offer and even as the ultimate justification for art in the schools. Indeed, a very prominent educator, speaking at a conference on arts in education, said that he expected the study of art to become a weapon in the war on drugs. For my own part, I dissent from such thoughts as these that attempt to vindicate art on the narrowly pragmatic grounds that it substitutes for reason by imparting knowledge to its audience in some other way. Putting aside the fact that there exists a lot of bad art inculcating perverse myths of concern, I seriously doubt if even art of high merit inevitably teaches us what we ought to think and do. True, art may correct logic itself on the right attitude to take towards children, but should we allow Homer to instruct us on the virtue of forbearance, Breughel on chastity, Tchaikovsky on serenity of spirit? Reason, to be sure, is not everything, but in most matters of judgment it is the best thing. The dignity of art, like the other forms of presentational symbolism, is that it is *pre*-rational, gets us ready to reason. But art must not be permitted to usurp reason's functions of knowing and deciding.

I feel that the really important function of art is contained in our apprehension of it, for through this intense concentration upon the artwork we seize the forms of consciousness that empower our minds. Both the other features in a good program of aesthetic education, performance and appreciation of cultural values, matter chiefly because they are the means by which students can pay closer attention to artworks. It has to be admitted that good results may come from appreciating cultural values in art and from making art; we might learn some ideas that we would not otherwise know, and we might even become artists ourselves. But important as these outcomes are, they remain ancillary to the real purpose of an aesthetic education program. The main thing is to apprehend art so intensely as to absorb from it the patterns and movements of consciousness in which we fulfill the possibilities inherent in our humanity.

What Must We Know about Art to Appreciate It?

The subject here is not the effect that artworks exert on our minds but rather the knowledge about an art form that we must apply in experiencing a work in order to get any good out of it. If two general points are made at the outset, the discussion can go forward more easily. And the first general point to be stated is the real existence of tacit knowledge or, as it is sometimes called, personal knowledge. By these terms I mean nothing

complicated or mysterious; I mean only that we all know a great many things without actually knowing that we know them. Our art experience especially testifies to this fact. I have already confessed musical ignorance, and yet I am able to read a fairly complex account of a musical selection from a record jacket as that piece is being played, an account which I could not begin to understand if I read it by itself without the music playing, and I can know at just what point in the music any particular part of the description applies. You can recognize a modulation in music without being able to define the term, you can sense the effect of an oriel window without knowing that it is called by that name, you can see the heavily saturated color in a painting without having the least notion what saturation is. Much of the knowledge that we need in order to apprehend art successfully is this tacit kind.

A second general point is that not all kinds of knowledge are equal in their uses and value. Although we have faith that all knowledge is good, we also realize that for certain purposes some knowledge is essential, other knowledge merely desirable or only optional. If you are going to drive your car properly, you must know what the car will do when the indicator is moved to different positions on the automatic shift. Knowing how to shift manually is less important for most drivers, and understanding the mechanics of the power train is hardly useful at all. If we keep in mind the kind of good that we derive from art experience, we can deduce what knowledge we need to have about an artwork in order best to obtain that good. The most valuable knowledge, I think, is exact information about that particular artwork just as an observable thing in itself, not information about the artwork's genre, not about the creator of it, nor about the times in which it was made, but information about the very object itself, the specific properties that make it just the artwork that it is and none other. Thus, if we want to apprehend Beethoven's Fifth Symphony, a good attending does not absolutely require that we learn about the development of the symphonic form and about Beethoven's place in that development. Nor will our attending be much improved by our knowing what Beethoven thought about music patrons or what was the status of Austria in European politics at the time the Fifth was composed. But, by contrast, a really good attending, one that fills and shapes our minds with the Symphony itself, will be aided by the knowledge that the tune of the first four notes is duplicated by the next four notes but in a lower key and that the notes following repeat the original tune again and again, first accelerating it and then slowing it back down.

The consequence of these two general points—first, that knowledge of art is to a large extent tacit or personal and therefore not utterable by those who possess it, and second, that the knowledge of art most worth having is specific to particular works of art and not information about genres, techniques, or eras of art—is that people do not need to behave with respect to art the same way that they typically behave towards most academic subjects. Foreign languages, natural sciences, and social science are

all of them systems of information about some aspect of the real world; they are about the "universe beyond the skin." Since the world is a universe—one continuous reality and not merely a jumble of things—different people ought to be able to see it pretty much in the same way and so to make the same statements about it. Therefore our knowledge about the conjugation of French verbs, the relation of weight to mass, and the marriage customs prevailing in various societies ought to be explicit, not tacit, and applicable to a wide range of phenomena, not particular to just the one case before us. But, as we have seen, artworks are not primarily about the world, the universe beyond the skin. Instead, they are expressions, literally "pushings out," projections, of the universe beneath the skin. They expose the intricate and highly varied mental stances that underlie all the different volitional, emotional, and intellectual acts that humans can perform.

As a result, the response to art of a school-age audience ought to be chiefly non-verbal. Teachers may find their students' silence unsettling, and they may even try to prevent it unless a coordinator helps them to see the importance of sheer contemplation in art experience. Most academic learning and teaching are very wordy. Both teachers and students are used to instructional formats of rapid fire question-and-answer colloquy interspersed with brief lecture, and even the project method of instruction often depends on words. Schooling makes us put a high value on words and causes us to distrust ineffable primary experience. Another result of these considerations is that the teaching of art appreciation should be highly specific and directed mainly towards teaching students to perceive the sensuous and formal properties of particular artworks just as objects worth knowing in themselves. This characteristic also may upset teachers. The mental activity which, as intellectuals, we most value is propositional knowledge involving generalization. Mathematics and the natural sciences all consist of propositions which apply to entire categories of things with even the variables regularized so that, for instance, the formulas of physics can tell us the weight on Mars or any other place of a person who weighs a hundred and thirty pounds here on earth. And such social sciences as economics and psychology at least aim to make universally true statements about their subject matter. By contrast, an artwork has not much actual subject matter, few objects or actions in the universe beyond the skin that it is really about; rather, it is an upwelling, a spontaneous outgoing, of mental phenomena. Therefore the separate, individual work is the thing that matters, not general and abstract statements concerning a whole class of things, but just this one concrete thing itself.

If we really believe that the best instruction teaches us how to think rather than what to think, then we will give a very full scope to art in our schools. The traditional academic disciplines teach us what to think; they are compendiums of knowledge, catalogues of what to think about this or that aspect of the objective world. But art expresses the inward world; it is the index to otherwise nearly inscrutable powers that only humans exercise, and it is by far the best means by which we and our students grasp

what those powers are and achieve some command of them. Once we understand that art functions very differently from the other disciplines, we will give it a large place in the curriculum of basic education, and we will teach it in a way that allows it to do its best work.

Getting Started

Suddenly starting up a full program is scarcely possible. Anyway, it is just as well to begin cautiously and to monitor the program and make changes in it that point it in the right direction while it is still new and more open to modification. From the beginning, coordinators should keep two efforts running simultaneously. The one effort—theoretical—is to gather ideas for forming and evaluating an aesthetic education program, and the other effort—practical—is to get an actual program started in the school.

Coordinators can best begin to form a theory of aesthetic education by realizing that this effort is a very long-term undertaking, one that can easily fill a whole career. One of the occupational rewards of teaching is being able to grow constantly, and the amount of good material on aesthetic education is more than enough to support the development of the most avid specialist. The coordinator should not be paralyzed at the outset by the sheer excess of opportunity, but rather should begin by picking up any one resource that is most attractive or nearest to hand and following it up until it leads to the next resource.

What resources exist? For one thing, courses in aesthetics and also in aesthetic education are available in universities and colleges, one in philosophy departments and the other in departments of education. Some coordinators might want to begin their preparation by taking some of these courses. A different first step into the field can be taken simply by writing the coordinator's state department of education and inquiring what they can offer in the way of curriculum material, syllabi, and useful addresses. Similarly, there will be a state and possibly a local arts council which can give various kinds of support. But the main source of coordinators' ideas will certainly be their reading. The reservoir of good professional reading is so large that coordinators could drown in it if they did not remind themselves that the literature of aesthetics and aesthetic education is not a subject for them to command but rather a source of critical thought that will both supply some ideas for teaching practice and also help them test the ideas which their own experience suggests to them. The point is that this material is most useful if it is read gradually, over a whole career, and not all in one condensed period. If practice and theory are what Tolstoy called them—what I do and what I think about what I do[6]—then the best plan is to carry them on together at a steady pace rather than obsessively tend to either one or the other.

The approach to reading that I recommend is to go to the periodicals first and to get from them a sense of the state of scholarly opinion and professional practice. Reading of books can come later. The range of available journals neatly covers the whole field. *Arts Education Policy Review* (formerly *Design for Arts in Education*) features substantial articles dealing with the practicalities of implementing aesthetic education programs. Articles in *The Journal of Aesthetic Education* stand a little farther back from the classroom to give a more general, philosophical outlook. *The Journal of Aesthetics and Art Criticism* prints articles and book reviews about aesthetics as an academic field in its own right.

From the beginning the program should be marked by certain traits. It should be experienced by all students in the school, since it is a basic subject for everyone and not a special subject catering to some particular clientele. To be sure, like any well taught subject, aesthetic education will be adapted to different students according to their differing levels of readiness. But there should be no mistaking the principle that the same basic program of learning to attend to artworks is offered to all. Therefore, wherever aesthetic education exists, it should be a mandatory subject, not an option. Second, since the program is basic, it has to be intellectually serious. Students at any level very quickly sort out the trifling work from serious study. To make any worthy contribution to basic education, this program will have to be seen by students, their teachers, and their parents as a direct stimulus to the growth of the mind. We have already seen that the study of art is substantially different from most academic study, but that fact is no excuse for softening aesthetic education into mere play and idle self-expression. The third characteristic which should be built into the program will probably be the most difficult to attain. It is accountability. With respect to education we are all empiricists at bottom. We might be willing to start up a program because of a theoretical justification, but we will insist on hard evidence from observation and testing before we agree to continue it. The question, what counts as evidence that a program has had a favorable impact on students, is almost always very hard to answer, but coordinators should try to answer it themselves if only to prevent its being dealt with by someone else who is less sympathetic to the program and less able to evaluate it.

In order to create a program that would manifest these characteristics at least in some degree I recommend that the coordinator begin by planning a unit of instruction that is wide in one respect but narrow in others. The unit should be broad, I feel, in the number of students affected. Involving every student in a school can be a practicable ideal if the unit is adapted to different grades. If that goal seems unmanageable to begin with, then a unit can be made for three grades, K-2 perhaps or 4-6, depending on the organization of the school. In any event, the unit should not be confined to gifted and talented, for most educators will be all too ready to brand aesthetic education an "enrichment activity," which is polite language for "frill."

I recommend two kinds of narrowness. Particularly just at first when the program is being instituted, coordinators should resist the expansive urge to name evocative but imprecise objectives but instead should try to find goals that the teachers in a school will understand. In a resource unit, the specific goals, which follow the more general objectives, should be explicitly and simply stated; they should be modest enough to allow for realization; they should be determinate. I am advocating that the goals be publicly stated so that teachers can have some guidance as they go beyond the coordinator's suggestions of methods of instruction and on their own look for additional classroom activities and material. Modest goals are achievable, and the program will gain adherents when teachers see successful fulfillment of the stated expectations. Finally, I want the specific goals to be determinate, not indefinite, in order to allow the coordinator to show that the students really did attain the experiences that were designed for them. Goals do not have to be behavioral to be determinate, but they must have a clear definition. For example, the goal statement, "Students will understand *Othello*," is not sufficiently precise to let us see whether the students really achieved the goal or not, but the goal, "Students will give likely explanations of Othello's gullible subservience to Iago," though not stated in behavioral terms, is concrete enough to be tested. As a result of these stipulations, the goals will be few, and therefore the unit can go forward briskly. (I assume that in elementary and middle schools the unit will be discontinuous, will be offered in small and discrete segments.)

The other desirable kind of narrowness is a very sharp focus of the activity in the unit on a single point of attending. To use Marshall McLuhan's words, art should be presented as a "hot" medium rather than "cool."[7] It should starkly concentrate attention on itself alone and not diffuse it over the surroundings, as happens, for instance, when we watch television, eat popcorn, and carry on a conversation all at the same time. An example of what I am warning against would be a thematic unit on ethnic heritage which would use Caribbean dancing, Native American jewelry, African folk tale, and Chinese calligraphy to illustrate the diverse background of the American people. Superficially one could argue for such a unit. Undoubtedly American students ought to realize that all the different elements in our population have a significant past encapsulated at least in some degree by their folk art, and of course each of the art forms mentioned here possesses enough aesthetic quality to deserve our students' attention. But I object to such a unit anyway, because its plethora of isolated artifacts—a bit of silver here, a touch of paint on paper there—will never cohere into a single point of engagement for the students. On the other hand, most communities contain aesthetically interesting objects. Earlier I gave as a case in point the fine houses and public buildings of Medina, New York. Here I can take as my example the automobile museum in Auburn, Indiana.

The museum exhibits a large collection of automobiles, mostly American, manufactured between the turn of the century and the 1950's, but the most outstanding designs are the Auburns, Cords, and Duesenbergs of the 1930's. In fact, these are very high powered cars, with engines producing as much as two hundred and sixty-five horsepower, but the illusion of force and speed which they convey far surpasses the reality. They are remarkable machines, but they are artworks too, made as much for contemplation as for movement and, like all good works of art, expressing virtualities which test and extend their spectators' vision of life. Those cars could be a focus for a vital unit in aesthetic education. The students' experience with these automobiles could be intensified by a saturation with related academic study. In English classes students might read such works about automobiles as Karl Shapiro's fine poems "Buick" and "Auto Wreck,"[8] and the students could write essays about the twentieth century's fascination with automobiles and what searchings and strivings that fascination represents. In social studies classes they could study the technical, economic, and political conditions that made possible the production of those complicated and expensive machines, and they could also examine the effect of the automobile on people's lives. Art classes could study the principles of design that make these cars so impressive and the development (and perhaps deterioration) of those principles over the years.

Both the units described above, the thematic unit on ethnic heritage and the automobile unit, employ academic learning, but fundamentally they are very different from each other. The thematic unit takes the attention that should go towards artworks and diverts it to concepts about society which can be better learned in other ways than through art; the automobile unit fixes attention on the point where students will want it to go—on the cars—and uses concepts to intensify the artistic vision. The thematic unit is diffuse; the automobile unit is concentrated. The artistic components of both units are worth presenting to students, but surely the cars are going to do the students more good of the kind that art can give than the scattering of objects in the thematic unit.

What, in detail, will good units in art apprehension look like? That question is dealt with in the next chapter.

FOOTNOTES

[1]A useful compendium of nuts-and-bolts information is *Arts and Education Handbook: A Guide to Productive Collaborations*, ed. Jonathan Katz (Washington, D. C.: National Assembly of State Arts Agencies, 1988).

[2]Harry S. Broudy, *Enlightened Cherishing: An Essay on Aesthetic Education,* (Urbana: University of Illinois Press, 1972).

[3]Two monographs setting forth the Getty program are *Beyond Creating: The Place for Art in America's Schools* (1985) and *Discipline-Based Art Education: What Forms Will It Take?* (1987), both published in Los Angeles by the J. Paul Getty Trust.

[4]*The Young Audiences Program Booklets: A Guide for Performing Artists, Booklet 4: The Process of Designing* (New York: Young Audiences, 1983), 5.

[5]Northrop Frye, "The Critical Path: An Essay on the Social Context of Literary Criticism," in *In Search of Literary Theory,* ed. Morton W. Bloomfield (Ithaca, NY: Cornell University Press, 1972), 93-193.

[6]Leo Tolstoy, *What Then Must We Do?,* trans. Aylmer Maude (London: Oxford University Press, 1960), 168. "Theory is what a man thinks on a subject, and practice is what he does."

[7]Marshall McLuhan, *Understanding Media: The Extensions of Man* (New York: McGraw-Hill, 1964), 22-23.

[8]Karl Shapiro, *Collected Poems, 1940-1978* (New York: Random House, 1978), 14 and 6.

CHAPTER EIGHT

Art in the Classroom

An Overview of Teaching Methods

Teaching students to apprehend art is a matter, first, of finding art-works which will capture and reward the students' attention and, then, of helping the works to arrest, hold, prolong, and shape that attention. If teachers do that much, the works by themselves will do the rest. I can say very little about selecting proper works that teachers who have any liking for art and sensitiveness to their students do not already know. Decisions about what artworks to present to students are based on such highly variable factors as the students' readiness, the nature of the school, the availability of artworks, the quality of local performers and even electronic equipment and other elements of presentation, and therefore those decisions almost have to be made *ad hoc*, each judgment formed to accord with the particular conditions prevailing in any one school.

On the other hand, some comments here about teaching methods may be in order. The methods exemplified in this chapter are thought out primarily with respect to art forms rather than grade levels or experience of students. Therefore, teachers who use them will want to select and revise in order to make them really suitable for differences of age and readiness. One principle dominates the generation of methods: it is that the right methods are the ones that concentrate students' attention on the artworks themselves and not on some activity tangential to that concentration. Any teacher knows that learning is an active process, something that vitally activates students' brains, hearts, and hands, not just something that they contemplate but something they effect, a positive act. On a superficial glance, therefore, the recommendations that follow may seem mostly fated to evoke in students a tamely passive and unduly quiescent response. But that is not really the case. A misunderstanding arises if a distinction is not made between *making* and *doing*. Both these states are activities, but one of them is external and therefore obvious, whereas the other is interior and less readily discernible. *Making* is an overt activity engaging us with the external world; it concerns the visible changes that we bring about in our homes, our neighborhoods, our workplaces, and, with luck, our churches, labor unions, and charitable organizations. *Doing*, by contrast, is an inward activity; it concerns the changes that we bring about, at an enormous expense of spirit, in our own hearts and minds.

In aesthetic learning students should engage in both kinds of activity so as to immerse themselves totally in the artwork and then to go on and reap the value of that work for themselves. The students' *making* will be a matter of some kind of outward creating. Thus, as the students get ready to watch a ballet performance, they will benefit from practicing a few simple poses and steps, a *tendu* in various directions, perhaps an *arabesque*, maybe a *glissade*. That sort of making will give them the feeling of "turn-out" and of sustaining a position, and it will help them to see these characteristics of good dancing when they attend the performance. A still more valuable kind of making will be experimentation with the posing and moving of bodies on a stage so as to create clear patterns, both static and mobile. But although making is always interesting, we know that any making of ours outside our own narrow specialties is necessarily crude and that the principal *educational* reason for engaging in it is to motivate our *doing*, that subtle reorganization of our vital powers that will support us when we go on to whatever kind of making we are really good at. To sum up, we do not look at statues to become sculptors, who are makers of one kind; rather we look at them for the ferment they create in us—the doing—that will help us to be better teachers, accountants, machinists, parents, or whatever other kind of maker we become in our own right.

So, then, some of these learning experiences will involve outward action that is obvious and often at least trivially social as, for instance, in a unit on music apprehension students' beating out rhythms as an activity, in a dance unit posing or performing combinations of steps in small groups and discussing the result, in a unit on theater reading dialogue aloud, in an architectural unit going on field trips and talking about the sights with fellow students. As teachers we feel comfortable with these activities of making, partly because they show that learning is going on, partly because we can control them. But the other kind of activity, doing, ought to happen too so that the students, all in their distinctive ways, can constitute the work and let it exert its beneficial influence over them. Even if we are uneasy about doing because of its privacy and ineffableness, still we should make plenty allowance for it anyway, because it is indispensable to an important aesthetic experience. As we saw earlier, although artworks are not a language, they are highly expressive. To learn their import, we must be alone with them, quiet and receptive.

In a unit leading to successful apprehending of an artwork students will have to be saturated with experiences of making and doing. Far more even than such ordinary cases of overlearning as memorizing the multiplication table or the alphabet, apprehending an artwork is a long process, and, unlike simple memorizing, it requires from students a high level of thought and feeling. So we should not just introduce students to the artwork; we should expand their experience of it until they live in it abundantly, interiorize it so intimately that it functions as a new element in their repertoire of mental action. The question arises, will they become bored

and want more variety? Their behavior in class and in auditoriums suggests an emphatic "no." Students get bored with art just as they do with anything else, but they never show boredom as a result of prolonged attention to an artwork that is suitable to them. They get bored, of course, by artworks that are too difficult, and they also get bored by unfavorable conditions of presentation such as faulty performers or uncomfortable and acoustically bad auditoriums or inadequate supervision.

But by far the most frequent cause of boredom, in my experience, is talk—whether teacher talk, performer talk, or even students' own talk. I have seen it happen so often in performing art that I am willing to lay down this general rule: while performance is going on students attend closely, but almost as soon as talk about the art begins their attention wanders. I have mentioned this rule to others who observe arts programs in the schools, and those others confirm my finding. Such a conclusion is not at all surprising, for the students are merely behaving the same way adults act. When we go to the theater we expect to see a play or hear a concert, not to attend a lecture, and we are rightly offended if someone comes out in front of the curtain and congratulates us on our luck in attending such a fine performance or exhorts us to contribute to the sponsoring organization or thanks every Tom, Dick, and Mary in the audience for their help in making the performance possible. What is wrong with such talk? After all, a play is full of talk too, and we do not complain about that. I think that talk which interferes with the experience of an artwork is bad because it requires the audience to make sudden shifts back and forth between two radically different kinds of symbolic activity. The artwork gives us a presentational symbolism, an isomorph of processes of thought or feeling or willing, whereas the discursive speaking/listening symbolism calls for judgments and decisions about the real world. (Will I sign that petition to the county legislature? Will I double my contribution to the local ballet company?) The presentational experience is diluted by the discursive interruptions. We adults, relatively powerful, react with such emphatic signs of irritation as storming out of the theater; the helpless students can do little more than fidget. In either case the spell of art is broken.

Here is a dilemma. At least to some degree we must talk about an artwork, give information concerning it, if our students are to apprehend it in its fullness of import and at its true worth. But talk, even talk about the artwork, dissipates the art experience into high-toned chitchat. Is there a way around this dilemma? Not really, I feel. And if we have to choose between the experience of art and information about art, then I cast my vote for the real thing—the experience of art itself. Even if the dilemma cannot be resolved, however, to some extent it can be eased through a couple common sense guidelines. One is to separate the art and the talk in time and, if possible, even in place; let the talk occur in the classroom; let the art occur in the auditorium or field trip. The other guideline is to minimize talk about art during the artistic experience; I would say that the talk/art ratio should never exceed 1/4, and the aim should be to make it lower than that.

A last point: I have already stated my conviction that art is below reason in the hierarchy of human intelligence and that the dignity of art is its being the matrix from which language and reason arise. I have not changed my opinion, and consequently I really do believe that as a general thing talk, which represents language and reason, is higher than art. But in this special circumstance of a vivid art experience reason itself has so much to gain ultimately that it should, for the moment, be subordinated to art.

This chapter presents some ways that really have been used to teach the apprehending of art. One complete resource unit in dance is given, and then a selection of activities for presenting music appears. The dance unit and the musical activities were devised for students from many different schools in grades 4-6, though, with some revision of the material to take account of students' previous experience the material could also be used with a wider grade range. Teachers who like these suggestions just as they are can directly institute them, but other teachers may find them more useful as focuses for criticism and reflection. In either case they will want to test the appropriateness of these units or suggested activities by asking the questions that should always arise in judging teaching plans. Here are some. Can my students really achieve the aims that are stated for them? Will meeting these specific goals allow my students to attain the larger aims? Which of the suggested activities will sufficiently challenge my students but not, through sheer difficulty, defeat and discourage them? What other activities will better suit my students than these that are stated? Are the suggested artworks the best ones for my students, or can I find others that will be more interesting to them? Do my students need to learn right now the ideas which this plan is designed to convey, or do they need other ideas more? A final point: not every item in students' apprehension of artworks can be foreseen by teachers, and therefore resource units and lesson plans should make allowance for unexpected responses as students deeply penetrate works and discover in them learnings which the teachers themselves did not notice.

Dance

This unit on dance was developed to maximize the educational impact on students of auditorium performances by a small group of classical dancers.

I. GENERAL OBJECTIVES

 A. To begin to acquire a tolerant readiness for new experience
 B. To become freely receptive to dance
 C. To watch and listen so intently as really to see the poses and movements and to hear the musical accompaniment

II. SPECIFIC GOALS

A. Enriching vocabulary from dance terms in general use
B. Understanding choreography as a deliberate planning that uses music, movement, posture, and costume
C. Seeing the shaping of space that occurs as dancers on stage change positions and poses
D. Hearing differences in tempos of music and perceiving the relations of dance movements to musical tempos
E. Understanding some of the ways that ballet reflects human relations and even history

III. VOCABULARY

A few special terms help discussion of dancers' performances. Probably teachers will not want to give direct instruction in these terms, but they ought to be ready with simple explanations of them when they naturally arise in discussion of the performance.

1. *Placement.* The relation that all parts of the dancer's body have to each other. Correct placement puts the head, neck, back, and legs in a straight line with less curvature in the lower back, a flatter abdomen, and a more raised instep than is characteristic of normal stature.

2. *Position.* One of five basic stances, each disposing the arms and legs in a particular way, and called "first position," "second position," and so on.

3. *Turn out.* The outward rotation of the legs from the pelvis downward through the feet. All the five basic positions employ turn out.

4. *Pointe, pointes* (plural). The very tips of a female dancer's feet. Dancing *en pointe* or *sur les pointes*, on the tips of the toes, began some time between 1810 and 1820 and was done in the soft slippers that male dancers still use. Over time, the ballet shoe for women was stiffened at the toe so as to produce the modern pointe shoe. (The common expression "toe dancing" may be strictly accurate, but it offends serious dancers.)

5. *Ballerina.* In common usage a female ballet dancer (at one time the male dancer was called a *ballerino*), but dancers confine the term to a female dancer of experience and accomplishment, one who has risen to top rank in a company.

6. *Corps de ballet.* Literally, "body of dance." The larger number of dancers on a stage who move in unison. Also the junior members of a

company. (Larger companies divide their dancers into anywhere from three to seven ranks according to their artistic accomplishment.)

7. *Elevation.* The height of a dancer's jump.

8. *Extension.* The height to which a dancer's leg is raised.

9. *Line.* The overall shape of a dancer's body in performance.

10. *Pas de deux.* Literally, "step [dance] of two [people]." A "pas de trois" is a dance for three, a "pas de quatre" for four, and so on. A classical *pas de deux* is a dance in four sections for a man and woman. In the first section the woman, supported by the man, displays her extensions; in the second section, known as the male variation, the man does steps of high elevation; the third section, the female variation, shows the woman dancer doing quicker steps of lower elevation and turns *en pointe*; in the fourth section the dancers, together again, execute virtuosistic steps to a quick tempo.

IV. SOME PRE-CONCERT ACTIVITIES

A. Show pictures of dancers in various settings and poses. Use pictures that illustrate the same or similar pose and ask what is alike from one photograph to another and what is different.

B. Ask how the dancers in the photographs look different from people as they normally appear. Dancers attempt to achieve a long, stretched but easy and spacious line, which can be quite different from their ordinary shape when they are not dancing.

C. Ask the following questions about body language. Can you tell anything about a person's character or state of mind by observing that person's carriage or walk? Can people express liking or disliking without using a word? How might a person convey the idea, without language, that this person is superior or inferior in rank to someone else?

D. Since they are not supposed to talk on stage, dancers use conventional gestures to mime certain meanings. Here are some expressions that dancers can mime: "I love you," "you are [or she is] beautiful," "it's dark," "I'm afraid," "no," "go away," "I have an idea." Ask students to guess what any of the gestures to indicate these meanings are. A hint: the gestures will have to be large for the audience to see them.

E. Inform students that the dancers will wear costumes. Survey the many kinds of costume and their uses: police, military, medical, judicial, religious. Notice that one reason for costume in sport is to allow

the audience to see what the athletes are doing with their bodies. Tennis players could play their game in baggy trousers, but we are glad they don't because we want to see their bodies and the way they move. It is exactly the same with dancers.

F. Review proper behavior. Unnecessary noises distract an audience. Unless some unusually fine dancing occurs, applause can best come at the end of a dance rather than during it. People who don't like a performance are free to say so, but they should withhold their comments until they are out of the auditorium. (Taking pictures, whether flash or otherwise, is wrong behavior, distracting both to dancers and audience and potentially dangerous.)

G. Assign the students an essay to be written before the performance: "What I Expect to See."

H. Get help from students in finding good pictures for the bulletin board. (See Section VI below.)

V. SOME POST-CONCERT ACTIVITIES

A. From time to time practice some of the simple exercises which were shown in the performance.

B. Invite students to revise the essay they wrote before, this time with the title: "What I Really Did See."

C. Discussion questions: "How is dance similar to sports?" "What sports does it most closely resemble?" "How is it different?"

D. Ask students to find in the pictures on the bulletin board any poses which they saw in the performance.

E. Ask students where dance can be seen locally. (This question and the resulting discussion will allow students to learn the location of leading theaters. If students know the whereabouts of these places, the means of getting tickets, the range of prices, and so on, their reluctance to attempt new experiences will be abated.) This question can be repeated over the year in order to keep interest in dance alive.

F. Encourage students to describe dance performances which they have seen. Teachers who tell of their own viewing of dance either in theaters or over television will provide their students with a persuasive model.

G. Keep students informed of approaching performances. A student who reads for the class's benefit the "Coming Events" column in the arts section of the local newspaper can provide this information.

H. A question which may lead to interesting discussion is this: "Why did people ever want to dance on their toes in the first place?" (Hint: ours is not the first generation that thought thin. One way to slim down the line of the body is to stand on the toes. Pictures in books on the history of fashion show early nineteenth century men and women of strikingly slender shape and very narrow feet.)

I. Another discussion question: "When a pair of dancers come out in front of the curtain, why does the man precede the woman, and if they take separate bows, why does he bow first?" (Answer: dance etiquette is based on ideas of politeness that existed in the Renaissance, when the most honored position in a procession was the last, a custom which is still observed in academic processions and religious ceremonies as well as in the order of bows in the theater.)

J. Ask students to look for situations or stories which can be expressed best by movement alone and those which cannot be well expressed by movement. (The choreographer George Balanchine once remarked that there is no way of putting two women on a stage and, without words, letting the audience know that the one is the other's mother-in-law.)

K. Invite a student to write up a review that a local newspaper might have published if this performance had been public. Begin by getting from the students information about the performance which the article might include.

VI. MATERIAL

The most widely available publication in this field, *Dance Magazine*, can usually be obtained in the larger sales outlets, but it is sufficiently interesting and useful to justify a school library's subscription. Since *Dance Magazine* contains many large photographs of contemporary dancers, the teacher who buys some issues will soon build up a good supply of fine material for showing on bulletin boards or illustrating mini lectures. Numerous dance films exist, but teachers should be prepared to go to some length to procure them. Film catalogues, and sometimes the films themselves, are available in the audio-visual departments of school districts, central libraries, and universities. Dance films, like any others, should be previewed by the teacher and chosen for their suitableness for the particular class that will see them. Except for technical analysis of steps and poses, video tapes are less satisfactory than film, for they diminish the sense of space which affects the proper viewing of dance.

Seeing a live performance by a good dance company in a real theater can be such a powerfully moving episode in anyone's life that schools should go out of their way to make it possible. Many schools are within commuting distance of this opportunity, and for them field trips are in or-

der, or teachers of secondary students can announce the times and places of coming performances and let their students manage for themselves. Arts appreciation clubs are a convenient means of arranging travel, the purchase of tickets, and the light supervision which will make parents and school authorities happier. Schools that are too far from metropolitan centers for easy commuting to the theater have a special problem, but if they can solve it they will give their students a real benefit. One solution is to incorporate the dance performance as a high point in a class excursion.

VII. BOOKS

Teachers desiring more information may want to consult the following books.

Crisp, Clement and Edward Thorpe. *The Colorful World of Ballet.* New York: Crown Publishers, 1978. This is a beautiful book of pictures with informative text and an illustrated description of a dance class. Anyone who looks it up in a well stocked library will find alongside it other books of dance photographs which are quite as fine.

Denby, Edwin. *Dancers, Buildings, and People in the Streets.* New York: Horizon Press, 1965. Dancer, poet, man of consummate cultivation, Denby is nearly everyone's choice as America's finest dance critic. He wrote about all the major dance forms with knowledge, experience, sympathy, and the power to express rare thoughts plainly.

Denby, Edwin. *Looking at the Dance.* New York: Horizon Press, 1968.

Kirstein, Lincoln. *Three Pamphlets Collected.* New York: Dance Horizons, 1967. The article "Ballet Alphabet" is a concise, clear, and informative explanation of basic terms in the special vocabulary of ballet. "What Ballet Is All About" gives the point of view on watching dance of a critic and art patron who for decades has been very close to the heart of American dance.

Kirstein, Lincoln. *A Short History of Classic Theatrical Dancing.* New York: Dance Horizons, 1969. One can quarrel with the word "short" in the title, but this work is vigorous, colorful, and informative.

Commentary

This resource unit illustrates some ideas about teaching good attending. The objectives have been held down to an attainable minimum, and they have been selected because they seem to be the powers most essential to an intelligent and devoted attending to dance. The goals are the

more determinate statements of particular abilities that altogether comprise the objectives. When I first worked on this unit some years ago I had misgivings about Goal II, E, which has to do with the connections of dance to history and anthropology, but I have since softened my objection to it. The issue involved, should artworks be used to convey general information and ideas, can get widely different resolutions. At one extreme is the view that, as a pure presentation of mental operations, the artwork should not be obscured by distracting references to the objective world; this is sometimes called the formalist view. At the other extreme is the notion that art has always been a vehicle for the beliefs that unite people within a culture and that it remains an effective means of inculcating values; this extreme is sometimes known as socialist realism. For reasons given in earlier chapters, I tend towards the formalist approach of concentrating on the artwork as a presentational symbolism of inner states and ignoring its relatively unimportant references to conditions in the outer world. But I also have come to realize that artworks in fact relate to the world either as it once was or is now or, most importantly, as it might become. Moreover, recognizing these relations can sometimes lend a real-life vigor to the apprehending of a work. So, with respect to dance, I hope that the students will eventually see it as a wordless and untranslatable presentation of some valuable permutations of mind, but I admit that they can make a beginning by recognizing, for instance, that the men and women in such a classical ballet as *Sleeping Beauty* illustrate a certain lofty ideal of the way the sexes might deal with each other and that the dancers' physical placement and deportment stand for an image that we can have of ourselves. Indeed, at this ideal level the representations which the artwork makes of the outer world are nearly indistinguishable from the presentations of states of consciousness.

Item IV, E, the discussion of costume in the suggested pre-concert activities section, may help to avoid an extremely embarrassing incident that sometimes destroys a school dance performance: the dancers come on stage dressed in tights, and someone in the audience sets up a hoot of derision, which is followed by a surge of snickers and occasional guffaws. Dance is probably the most egregious case, but the same disorder can occur in the presentation of the other arts as well. The unfamiliarity of seeing and hearing actors deliberately express feeling rather than repress it, which is the more usual action in the real world, can confuse students to the degree that they mask their discomfort with dismissive laughter, or the strenuousness with which musicians have to attack their work can strike an immature audience as ridiculous.

I confess that when I see such an episode I become angry with the vulgarity of the students and horrified with the barbarism of a culture in which such conduct happens. But I have made this confession only to dismiss the anger from my own mind and, vicariously, from my reader's. Outrage at the savaging of art is, in my opinion, just, but I know that it does no good whatever in affecting the behavior of these unruly students.

And once my anger dies down, I feel more tolerant about them. Jacques Barzun remarked that no one is born human.[1] The application of that remark to these students is that they have to be made ready to undergo a kind of experience that is new to them. So by intimating just in an informal, matter-of-fact way that the dancers will be wearing tights and that their costuming is a part of the performance, the teacher may be able to prevent an unpleasant incident and at the same time help the students to fasten without shame on an important aspect of dance, the deliberate exposure of the body and its movements. Students whose aesthetic awareness has been formed largely by television and radio will often need to make a special effort to acclimate themselves to performances of serious art.

Music

In place of a full resource unit, this section describes a variety of activities designed to help students apprehend music. Of course, aesthetic education involves students at different levels, and the same activities that suit young or musically disadvantaged students will not always interest older or more experienced ones. Just as inexperienced listeners can be turned off from music by activities that are discouragingly difficult, so the more skilled listeners may be offended if they imagine that the teacher is patronizing them. The musical selections as well as the activities should be chosen circumspectly. In general, the more experienced listeners will have broader taste and tolerance, and less acute listeners will need simpler, more directly apprehendable music. For instance, the symphonies of Brahms will probably be within the range of most high school students, but younger students will respond with greater zest to such music as the overtures, preludes, and marches of Offenbach, Wagner, Smetana, and Tchaikovsky.

Like the resource unit on dance, these activities have been devised in light of the principle of saturation which was mentioned earlier in this chapter. For me the term *saturation* does not refer to the number of artworks one apprehends or even to the amount of time one spends in their company. Instead, it is the density, the thickness, of the experience they provoke. Most everyday experience runs through consciousness like water through a sieve. A good experience of an artwork has the opposite effect: it is thick, and so it stands out in the mind. This quality of thickness, this saturation, can best be attained by readiness to pay close attention, and these activities are aimed to increase that readiness. They arouse students' attention by giving clarifying information or hints of features to look for; they prolong and deepen attention by pointing to previously unnoticed features and by inviting students to revisit the work and constitute it once again.

Activities for Appehending Music

1. Finding Rhythms

A good place to begin in teaching inexperienced students is naturally occurring rhythms. Some examples appear below. Teachers can offer a few of them for illustration and motivation and then invite students to find other examples on their own. In some cases—e.g., different kinds of lawn sprinkler with their characteristic tempos—students can beat out the rhythm.

a train traveling at any speed over a railway track
an airplane engine warming up or winding down
an automobile driving over the regular divisions in a cement road
skipping rope
heart beat
lawn sprinkler
a dog's barking, a frog's croaking
walking or running
typing of an accomplished typist
speech patterns in assertions, questions, exclamations
a dripping faucet
bicycling up a hill, then down
bird song

When students analyze any such rhythms, they will find one or another of the following components:

A. A regular BEAT.

B. An ACCENT (emphasis) on one beat out of a series of beats. Most bird songs are highly accented.

C. Alternatively, a lack of ACCENT, which, for instance, usually characterizes a dog's barking.

D. Sometimes a slowing or quickening of TEMPO, as illustrated in the greater lapse of time between beats as a runner comes to a halt or the shorter space between them when the rope jumper speeds up.

E. Sometimes a rising or falling in PITCH, as in an airplane engine's warming up and then slowing.

F. Sometimes an increase in DYNAMIC LEVEL or a decrease, such as the differences we hear when a vehicle drives towards us (crescendo), then drives away from us (diminuendo).

Beat, accent, tempo, pitch, dynamics; by explicitly identifying these musical elements, students will greatly increase their power to hear serious music accurately and to discuss their impression of it intelligently.

2. Hearing Melodies

A grasp of the elements of music will help students to recognize melody. Musical selections which can serve for practice are the opening scene (the railway passenger car) in *The Music Man*, Rossini's *William Tell Overture*, and the fourth and fifth movements of Beethoven's Sixth Symphony. Here are suggestions for presenting these selections.

A. *The Music Man.* Before listening to the music, students can be asked to beat out the characteristic rhythm of a train running down a track and then to listen for that rhythm in this selection. After they have heard the music, they can be asked if this train travels at the same speed throughout or at different speeds.

B. *William Tell Overture.* Since this is a short selection, the teacher can play the entire overture. It has two especially memorable passages, the music depicting a storm and the music at the end which was to become The Lone Ranger theme of the famous radio Western drama series. The storm music alone can be played again for closer analysis. The teacher can ask which aspect of the storm is presented—the thunder? the lightning? the wind?—and also if the storm is approaching the listener or retreating. The storm segment in the fourth movement of the Beethoven Sixth makes interesting comparison. Beethoven's storm, for instance, is longer and more full of incident, but Rossini's is more violent. Unlike Rossini's storm, Beethoven's has an "eye" of quiescence within the turbulence surrounding it. Even though the section which was to become The Lone Ranger theme was not originally intended to allude to a horse's movements, in at least two respects it is apt: clearly this horse is galloping, not just walking or trotting, and its four feet touch the ground, as is the case with horses, not quite simultaneously.

C. Beethoven's Sixth Symphony. After the storm subsides, this symphony concludes with a rondo movement, that is, a movement in which the first, principal melody recurs a number of times with other melodies interspersed. At the outset of this last movement the main melody is very simple, but after the early statement Beethoven exercises all sorts of elaboration. With a little help from the teacher students will be able to recognize variations in dynamics, pitch, tempo, and accent which transform a plain melody into a complex one.

3. Sensing the Illusion of Movement in a Selection

The teacher can play short selections and ask which words out of a list of adjectives best describe the sensations of movement embodied in the

piece. Such a list might include *slow-fast, near-far, gradual-abrupt, increasing-diminishing, retreating-advancing, hovering-proceeding, ascending-falling, expanding-collapsing.* Specific selections will suggest other pairs. If students help to find the contrasting pairs of words, they will learn more from this activity.

4. Becoming Acquainted with Certain Selections

A. Richard Wagner, "The Ride of the Valkyries." The more familiarity students have with this thrilling music the fuller and more accurate their sense of it will become. Since the Ring cycle of four operas is much too complex for any summary that would make sense to most school children, probably it is enough for teachers to say that the Valkyries in the story are female spirits who protect the souls of heroes slain in battle and guide those souls to heaven. After students first hear this music, the following questions may help them to clarify their impression of it. Why is the music not boring in spite of its repeating the same melody over and over? (The fact is, some hearers do find Wagner boring—not everyone likes everything.) Does the music present the Valkyries as in the air or on the ground? Are they coming towards us or going away from us? Do they seem to travel a short distance or long? fast or slow? A motion picture director used this music to accompany the shot of helicopters flying over a village and bombing it. What makes this music a good choice for that scene?

B. Saint-Saëns, *Danse Macabre.* This selection illustrates an extreme of program music, a tone poem designed to duplicate the sensations evoked by a literary work. In this instance the work was a poem of the same name by Henri Cazalis. The poem shows the figure of Death playing a fiddle at night, skeletons aroused from their graves dancing in a frenzy around the graveyard, their bones clicking, and then, when the rooster's crow announces the coming of the dawn, the flight of the skeletons and the sudden calm. Saint-Saëns' composition is very literal, and students may be able to guess the correspondences between the tone poem and the word poem, such points as Death's playing a dance tune, the running and jumping of the skeletons, the sudden halt in the dancing, the resumption of the dance, the rooster's crow, and the disappearance of the spectral company.

C. Respighi, *The Pines Of Rome.* The section of this work that should be played is Part III: "The Pines of the Janiculum." Much like the nightingale itself, which sings in this segment, the beauty of the selection is secretive and must be sought out by close and intense listening. A possible approach here is to play the selection several times, repeating especially the measures just before and just after the nightingale sings its song. When a student has detected the elusive melody, that student can sing or hum it so that the rest of the class hears it.

D. Handel. "The Arrival of the Queen of Sheba." Why would such a title as *Washington Redskins Score a Touchdown* be inappropriate for this selection? Consider the application of the following words: *solemn, joyous, jolly, airy, breezy, sweeping.* Which words would best convey the atmosphere of the selection? Are any of the words true in some way but also misleading?

5. Students can practice the production of sound by blowing across a pop bottle.

6. The teacher can play on a piano or guitar, or let a student play, the theme of Offenbach's "Can Can" or some other simple tune. The theme can be played loud and then soft, fast-moderate-slow, with more or less accent on particular notes. The class can be asked in what ways the particular renderings differ and which version seems best.

7. The role of the conductor can be discussed and the students can experiment with leading their classmates in a song. The ways that conductors call for louder or softer sound and for slower or faster tempo can be described.

8. A project can be designed to explore the different lengths of tube as they determine high pitch *versus* low pitch. Tubing of plastic, cardboard, or rubber of greatly varying lengths is "buzzed," i.e., blown across, and the resulting sounds compared.

9. Bottles and canisters can be filled with water to different heights and either struck or blown across and compared for the resulting sounds. The quality of sound is affected by the material of the instrument as well as by the instrument's volume and shape.

10. Students can be asked to collect pictures of as many different instruments as possible for a bulletin board display. They can arrange the pictures in different ways: according to the instruments' primary association with popular music or classical or folk; according to their belonging to the family of brass, woodwind, string, or percussion; or according to the location they occupy in a classical orchestra when it is performing.

11. The students can keep a journal of the music they hear and then discuss the difference between casual "hearing" and intense "listening." They should try to distinguish the times when they merely hear and when they seriously listen.

12. The idea of repetition in music can be explored by singing such simple canons or rounds as "Three Blind Mice" or "Row, Row, Row Your Boat." Then a fugue can be played and students asked if they can identify its distinctive feature.

13. Students can invent their own musical instruments. A simple rhythm instrument can be made by putting some rice or dried beans in an empty coffee can. Other items that can be used to make a musical instrument include rubber bands, cardboard tubes and boxes, old keys hung on strings, wooden blocks and dowels, old pots and pans, and clay flowerpots.

14. An exercise in recognizing rhythms can be devised. The exact form and complexity of the exercise will vary according to the students' maturity and experience with music. A simple exercise calls for the students to combine two beats, which can easily be represented by clapping the hands. The possibilities of combining just two beats are: one-two (unaccented); ONE-two (accented first beat); one-TWO (accented second beat). A basic rhythm can be complicated by being played in slow, fast, or medium tempo. Additional complications can be gained by mixing differently accented measures, e.g., one-two, one-TWO, one-two *versus* one-TWO, one-two, one-TWO. A three beat phrase increases the possibility of variety.

15. The students can be asked to find words to describe the music they have heard (e.g., *high, soft, fast*).

16 The use of semantic differential scales can help students specify for themselves the effect which passages of music have for them. For instance, where do they think the beginning of the third movement of the Tchaikovsky Sixth Symphony should be placed on each of the following scales?

 fast...slow
 loud...soft
 long melody...short melody
 single melody...multiple melodies
 simple repetition....................................variation

17. Two short passages with the same marking can be played—e.g., the allegro con brio beginning of the first movements of Beethoven's Third and Fifth Symphonies—and the students asked how the two passages are alike, how unlike. Passages differing from each other in varying degrees can be chosen according to the level of discrimination which different groups of students have acquired.

FOOTNOTE

[1]Jacques Barzun, *Teacher in America* (Boston: Little, Brown, 1945), 13.

WORKS CITED

Arnold, Matthew. *The Complete Prose Works of Matthew Arnold.* 11 vols. Edited by R. H. Super. Ann Arbor: University of Michigan Press, 1960-1977.

Ball, Michael R. *Professional Wrestling as Ritual Drama in American Pop Culture.* Dyfed, Wales: Edwin Mellen Press, 1990.

Barzun, Jacques. *Teacher in America.* Boston: Little, Brown, 1945.

Beardsley, Monroe C. *Aesthetics from Classical Greece to the Present: A Short History.* New York: Macmillan Co., 1966. Reprint. University, AL: University of Alabama Press, 1975.

Bell, Quentin. *Bad Art.* Chicago: University of Chicago Press, 1989.

Boswell, James. *The Life of Samuel Johnson, LL. D.* Edited by R. W. Chapman. Oxford Standard Authors. London: Oxford University Press, 1953.

Bronowski, Jacob. "The Reach of Imagination" *Proceedings of the American Academy of Arts and Letters and National Institute.* Second Series, Number Seventeen, 1967. Reprinted in *The Folio Anthology of Essays.* Edited by Frank Delaney. London: The Folio Society, 1990.

Brooks, Cleanth, and Robert Penn Warren. *Understanding Poetry.* 4th ed. New York: Holt, Rinehart and Winston, 1976.

Broudy, Harry S. *Enlightened Cherishing: An Essay on Aesthetic Education.* Urbana: University of Illinois Press, 1972.

_____. The *Uses of Schooling.* New York and London: Routledge & Kegan Paul, 1988.

Crisp, Clement and Edward Thorpe. *The Colorful World of Ballet.* New York: Crown Publishers, 1978.

Denby, Edwin. *Dancers, Buildings, and People in the Streets.* New York: Horizon Press, 1965.

_____. *Looking at the Dance.* New York: Horizon Press, 1968.

Dewey, John. *Art as Experience.* New York: G. P. Putnam's sons, 1958.

Ducasse, Curt J. *The Philosophy of Art.* New York: Dial Press, 1929.

Frye, Northrop. "The Critical Path: An Essay on the Social Context of Literary Theory." In *The Search for Literary Theory.* Edited by Morton W. Bloomfield. Ithaca, NY: Cornell University Press, 1972.

Gagné, Robert M. *The Conditions of Learning and the Theory of Instruction.* 4th ed. Fort Worth: Holt, Rinehart, and Winston, 1985.

Gay, Peter. *Freud: A Life for Our Times.* New York: Norton, 1988.

J. Paul Getty Trust. *Beyond Creating: The Place for Art in America's Schools.* Los Angeles: J. Paul Getty Trust.

_____. *Discipline-Based Art Education: What Forms Will It Take?* Los Angeles: J. Paul Getty Trust, 1987.

Hirsch, E. D., Jr., *Cultural Literacy: What Every American Needs to Know.* New York: Random Rouse, 1988.

Hodges, Alan. *Alan Turing: The Enigma.* New York: Simon and Shuster, 1983.

"Imagination Celebrations Link the Arts and Education." *New York Teacher* 32 (25 June 1990): 20.

Ingarden, Roman. "Artistic and Aesthetic Values." In *Aesthetics*, edited by Harold Osborne. London: Oxford University Press, 1972.

Kael, Pauline. *5001 Nights at the Movies: A Guide from A to Z.* New York: Holt, Rinehart, and Winston, 1982.

Kael, Pauline. *Hooked.* New York: Dutton, 1989.

Katz, Jonathan, ed. *Arts and Education Handbook: A Guide to Productive Collaborations.* Washington, D.C.: National Assembly of State Arts Agencies, 1988.

Köhler, Wolfgang. *The Mentality of Apes.* Translated by Ella Winter. 2nd ed. London: Routledge &Kegan Paul, 1956.

Kirstein, Lincoln. *Three Pamphlets Collected.* New York: Dance Horizons, 1967.

_____. *A Short History of Classic Theatrical Dancing.* New York: Dance Horizons, 1969.

Kopkind, Andrew. "Medium Gains." *The Nation* 7 (3 October 1987): 327-328.

Lakoff, George, and Mark Johnson. *Metaphors We Live By.* Chicago: University of Chicago Press, 1980.

Langer, Susanne K. *Feeling and Form: A Theory of Art Developed from "Philosophy in a New Key."* London: Routledge & Kegan Paul, 1953.

_____. *Philosophy in a New Key: A Study in the Symbolism of Reason, Rite, and Art.* 3rd ed. Cambridge, MA: Harvard University Press, 1957.

_____. *Mind: An Essay on Human Feeling.* 3 vols. Baltimore: Johns Hopkins University Press, 1967-1982.

Lewis, C. S. *The Allegory of Love: A Study in Medieval Tradition.* London: Oxford University Press, 1936.

McLuhan, Marshall. *Understanding Media: The Extensions of Man.* New York: McGraw-Hill, 1964.

Osborne, Harold. *Aesthetics and Art Theory: An Historical Introduction.* New York: Dutton, 1970.

Perrine, Lawrence. *Sound and Sense: An Introduction to Poetry.* 7th ed. New York: Harcourt, Brace, and Janovich, 1987.

Piaget, Jean. *The Language and Thought of the Child.* Translated by Marjorie and Ruth Gabain. 3rd ed. London: Routledge & Kegan Paul, 1959.

Porter, Fairfield. *Thomas Eakins.* New York: George Braziller, 1959.

Richards, I. A. *Principles of Literary Criticism.* New York: Harcourt, Brace, 1952.

Sacks, Oliver. *The Man Who Mistook His Wife for a Hat and Other Clinical Tales.* New York: Summit Books, 1985.

Santayana, George. *Reason in Art.* Vol. 4 of *The Life of Reason; or The Phases of Human Progress.* New York: Charles Scribner's Sons, 1905. Reprint. New York: Dover, 1982.

Schiller, Friedrich von. *Letters on the Aesthetic Education of Man.* Translated by Reginald Snell. New Haven: Yale University Press, 1954.

Shapiro, Karl. *Collected Poems, 1940-1978.* New York: Random House, 1978.

Shelley, Percy B. *Shelley's Critical Prose*. Edited by Bruce R. McElderry, Jr. Lincoln: University of Nebraska Press, 1967.

Skinner, B. F. *Beyond Freedom and Dignity*. New York: Alfred A. Knoff, 1971.

Smith, Ralph A. *The Sense of Art: A Study in Aesthetic Education*. New York and London: Routledge & Kegan Paul, 1989.

Tolstoy, Leo. *What Then Must We Do?* Translated by Aylmer Maude. London: Oxford University Press, 1960.

Unamuno, Miguel de. *The Tragic Sense of Life*. Translated by J. E. Crawford Flitch. New York: Dover, 1954.

Unger, Leonard. *The Man in the Name*. Minneapolis: University of Minnesota Press, 1956.

Vygotsky, Lev Semenovich. *Thought and Language*. Edited and Translated by Eugenia Hanfman and Gertrude Vakar. Cambridge, MA: M.I.T. Press, 1962.

Young Audiences. *The Young Audiences Program Booklets: A Guide for Performing Artists, Booklet 4: The Process of Designing*. New York: Young Audiences, 1983.

INDEX

Adams, Richard, *Watership Down*, 42
Aesthetic attending, abundance in, 3-5, 68, 69
Aesthetic education and academic instruction contrasted, 90-91
Aesthetic education coordinator, sources of information for, 91-92
Aesthetic education programs, characteristics of, 92-94; components of, 83-88; goals of, 93; resources for, 80-82; starting up, 91-94; teaching methods in, 97-100; units, 94, 100-105
Aesthetic judgments, reliability of, 73
Allen, Fred, 6
Allen Woody: *Annie Hall*, 6
Apprehending music, activities for, 107-112
Aristotle, 85; *Politics*, 14
Arnold, Matthew: "The Function of Criticism," x; "Shelley," 73
Art and attention, 16-17; art and dream, 20; art and ethics, 13-15; art and language, 15; art and morality, 40-41; art and reason, vii-viii, x, 64, 87, 100; art and wholeness, 17-18
Art as isomorph of consciousness, 18-22
Art, equivocal meanings of, 67
Art objects and artworks contrasted, 10
Art, tacit knowledge of, 88-89
Arts Education Policy Review, 92
Artworks as intelligible objects, 7
Artworks, most desirable knowledge of, 89
Attending, 3-5; features of: abundance, 69; intensity, 68; order, 69
Auburn, Indiana, automobile museum, 94

Bad art distinguished from good, 44
Bad art: about animals, 42; pornography, 42-44; professional wrestling, 37-38
Balanchine, George, 104; *Agon, Concerto Barocco*, 69
Ball, Michael: *Professional Wrestling as Ritual Drama in American Pop Culture*, 51
Barzun, Jacques: *Teacher in America*, 107

Beardsley, Monroe C.: *Aesthetics from Classical Greece to the Present*, 11
Beethoven, Ludvig van, his difference from Haydn, 5; Symphony No. 3, 112; Symphony No. 5, 57, 89; Symphony No. 6, 109; Symphony No. 9, viii
Bell, Quentin: *Bad Art*, 51
Benny, Jack, 6
Bible, 18
Brecht, Berthold, *Mother Courage*, 60
Breughel, Pieter, 88
Bronowski, Jacob: "The Reach of Imagination," 52
Brooks, Cleanth and Robert Penn Warren: *Understanding Poetry*, 74
Broudy, Harry S.: *The Uses of Schooling*, 14; *Enlightened Cherishing*, 82
Bruckner: Symphony No. 9. 72

Cassatt, Mary, 87
Cemeteries as artworks, 44-45, 50-51
Cézanne, Paul, 71
Chaplin, Charley: *City Lights*, 40-41
Chartres Cathedral, 76
Cognitive strategies, 55
Communication, 46
Connotation and denotation, 56-59
Constituting, 8-11
Crisp, Clement, and Edward Thorpe: *The Colorful World of Ballet*, 105
Croce, Arlene, 74
Croce, Benedetto, 1
Cultural values, 87-88

Da Vinci, Leonardo, 5
Dance Magazine, 104
Dante, 18
Denby, Edwin: *Dancers, Buildings, and People in the Streets*; *Looking at the Dance*, 74, 105
Dewey, John: *Art as Experience*, 1
Doing and making contrasted, 97-98
Dostoevsky, Fyodor: *Crime and Punishment*, 76
Ducasse, Curt J.: *The Philosophy of Art*, 11

Eakins, Thomas: *Max Schmitt in a Single Skull*, 9-10
Experience, varieties of, 1

Fitzgerald, F. Scott, 81
"Frankie and Johnny," 49
Freud, 20

DATE DUE

MAR 3 1 2003	
APR 2 3 2003	
DEC 0 7 2003	
APR 2 9 2004	
MAY 2 7 2004	
NOV 0 7 2005	

DEMCO, INC. 38-2931